Boston's NORTH SHORE

Boston's

North Shore

Photographs by Ulrike Welsch

Commonwealth Editions

Beverly, Massachusetts

ISBN 1-889833-53-3

Text by Webster Bull.
Jacket and interior design by Joyce Weston.
Printed in Korea.

Published by Commonwealth Editions,
an imprint of Memoirs Unlimited, Inc.,
266 Cabot Street, Beverly, Massachusetts 01915.

Visit our Web site: www.commonwealtheditions.com.

To sample Ulrike Welsch's archive of international photographs, visit
www.ulrikewelschphotos.com.

Front jacket: Annisquam Light, Gloucester
Back jacket: Dressage warmup, Hamilton
Endpapers: Plum Island Sound from Great Neck, Ipswich
Title page: Fort Sewall, Marblehead
Page v: Heron, Parker River Wildlife Sanctuary, Plum Island
Page vi: Schooner *Thomas E. Lannon*, Eastern Point Light, Gloucester

CONTENTS

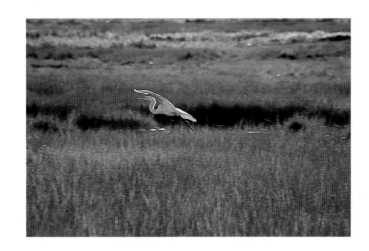

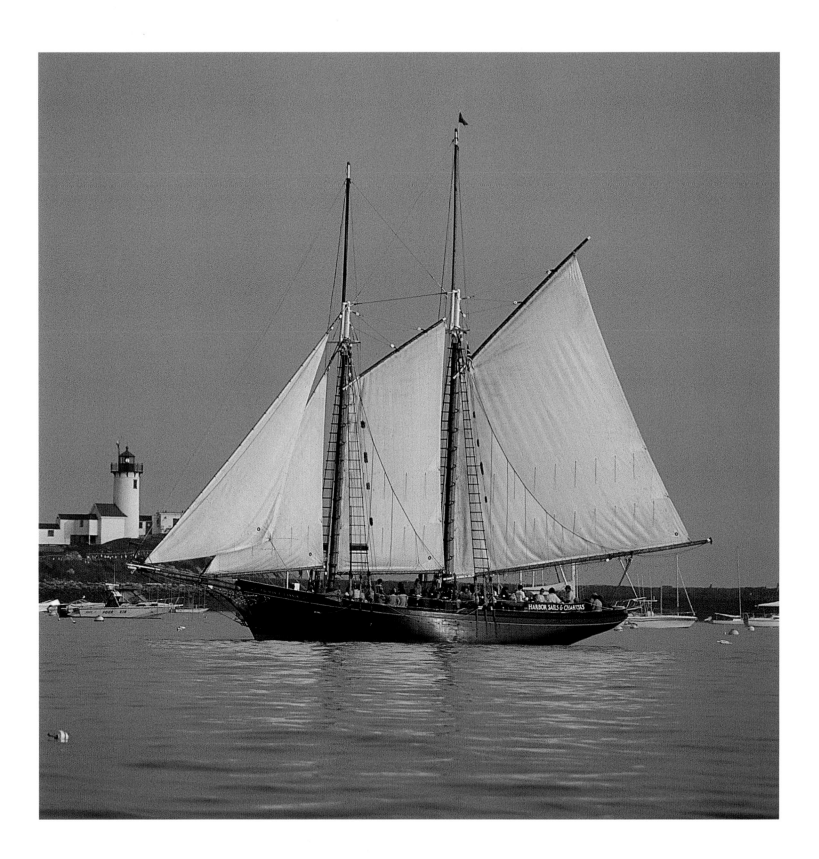

FOREWORD

B OSTON HAS NEVER had a shore to speak of, not to the north anyway, where the Mystic River empties into the harbor and the Boston waterfront is studded with wharves. A North End, yes, but a North Shore? That was a latter-day creation.

Not until transportation of one kind and then another carried Bostonians out of their city did Boston acquire a shore up thataway. The stage carried eighteenth century travelers north along the Old Boston Road and Salem Turnpike. In the nineteenth century, the quicker, if noisier, iron horse chuffed and pushed farther still, to Cape Ann and eventually to Newburyport. More recently, the motorcar—and the modern highway system—has stretched our definition of Boston's North Shore to an almost absurd limit, the New Hampshire border. Unless the good citizens of Portsmouth submit to colonization by Boston, the stretching likely will end there.

The economic and ethnic makeup of the shore has changed just as much. English at the outset and Brahmin in the nineteenth century, when city gentry discovered Nahant and the so-called Gold Coast from Beverly to Magnolia, Boston's North Shore is now and is likely to remain a tasty bouillabaisse of cultures. Lynn is its own melting pot. Once one of the largest cities in the Commonwealth of Massachusetts, the shoemaking capital of the country, and the world's leading maker of ladies' shoes, Lynn has staged comebacks again and again. Salem and Newburyport, once maritime powers and subsequently revived by light industry, fell on hard times after World War II but have rebounded with recent redevelopment. Gloucester, so dependent on fishing, has sailed on despite overfishing of the banks and government regulation of the fisheries. Who knows what Revere, once a legendary summer haven, will be twenty years from now? Will Ipswich or Rockport ever change? Those who live there hope not.

While the fortunes of the once-dominant cities of the shore—Lynn, Salem, Gloucester, and Newburyport primarily—have risen and fallen with long-term economic cycles, those of the towns gathered around them, especially the small ones, have remained far more constant. In Nahant, in Magnolia, on Plum Island, as in Ipswich, Rockport, Rowley, and Amesbury, the pace of life is slower, the streets narrower, the times more refreshingly backward. A dog still lazes in the street. The postman smiles and calls you by name. To be so close to Boston—and yet so close to up-country New England—is what makes living on Boston's North Shore such a joy.

And so close to the sea. Even in Revere, huddled near the city's towers and the airport's roar, the ocean lies at the end of every cross street. Farther up the shore, it is perhaps the proximity of forest and surf, with stripes of marsh and ledge between them, that defines this part of the world. Stone walls crisscross the upper shore, where farming was once a way of life. In some places, the forests have regrown themselves, but elsewhere estates and, now, more efficient structures have replaced the farms. But drive up Route 1A above Ipswich on a sunny Sunday, and you'll see enough horses, tractors, and furrows to recall early times. Essex Aggie and the Topsfield Fair are not here by accident.

Driving is the best way to see the North Shore. You can fly over it, as Ulrike Welsch did for some of the photos in this book, and you can sail or paddle past it, as generations have done, after and certainly before the arrival of European settlers. But with its back roads and shade trees, its sweeping landscapes and sudden ocean vistas, Boston's North Shore was built for a Sunday drive on a Tuesday morning or Friday evening. If you want to go shopping, use the highways—95 and especially 128. If you want to see what life here is all about, 1A, 114, 127, 133, and other numbers on white signs are the ones for you.

❧

Ulrike Welsch is the photographer for Boston's North Shore. When I first conceived the idea of collecting North Shore photos—in a wall calendar for the year 2000—I thought I would gather a single image from each of a dozen artists. Then Uli, as friends know her, sent me a few hundred pictures culled from a career of artistry. In a second I realized, why haggle with twelve photographers when I could have the best all in one?

Uli has lived in Marblehead for going on four decades, yet she didn't come by it as "Marbleheaders" do, which is to say she wasn't born in the Mary E. Alley Hospital. Uli is from Germany, by way of the *Boston Globe*, where she was the first female photojournalist in the paper's history. Since 1981, she has worked freelance, gathering breathtaking images from annual junkets to places as strange as Mongolia, Peru, and Montana. Yet she has always kept an eye open to the region that adopted her, Boston's North Shore. And the proof, gentle reader, is in this volume.

Together, we compiled calendars for 2000, 2001, and 2002. Along the way, Uli created the galleries that became the books *Marblehead* (2000) and *Boston Rediscovered* (2002). With the publication of *Boston's North Shore* in 2003, we continue a completely satisfying partnership of artist and publisher. I am proud to say that Uli Welsch is my friend and equally proud that her work is a cornerstone of Commonwealth Editions' list.

Webster Bull, publisher
April 2003

Boston's NORTH SHORE

THE LOWER SHORE

As you exit the Callahan Tunnel or Logan Airport and head north along the shore on Route 1A, the prospect seems mixed. The only farm here is the tank farm, where oil tankers unload and oil trucks take on their liquid cargo. Like the margin of every great city, this area grinds with its share of noise and teems with overdevelopment.

But drive a little farther and look a little deeper.

With Boston looming over their shoulders, the communities of Revere, Winthrop, Saugus, Lynn, Nahant, and Swampscott offer the first promise of escape from the city's heat and hurry. Escape here takes many forms—from the thrill of the horse and dog tracks to the echo of a long-gone hurdy-gurdy on Revere Beach, from a quiet paddle in a kayak through Saugus marshland to a plunge into the surf off Swampscott, from a sunny day in Nahant to a winter's walk in Lynn Woods.

The North Shore begins with one of the most revered names in American history. As the names Revere and Winthrop suggest, history is hidden everywhere here. You only need to know where to look. And the ocean lies always to the east, at the end, it seems, of every side road. Ten degrees cooler in the summer, ten warmer in winter, life along the shore—lower, middle, or upper—is simply more suited to human habitation than landlocked life.

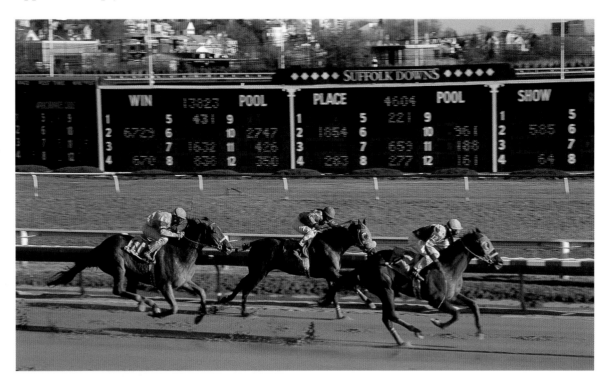

Racers at Suffolk Downs in Revere enter the home stretch. The Boston skyline looms in the distance.

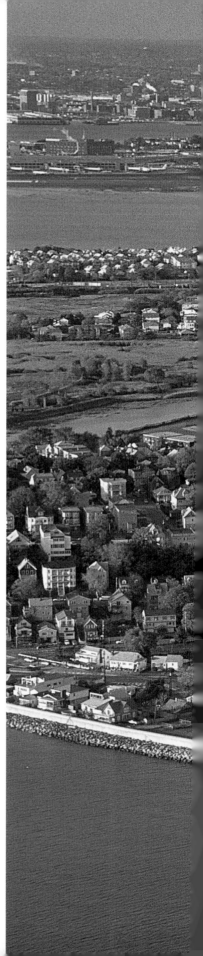

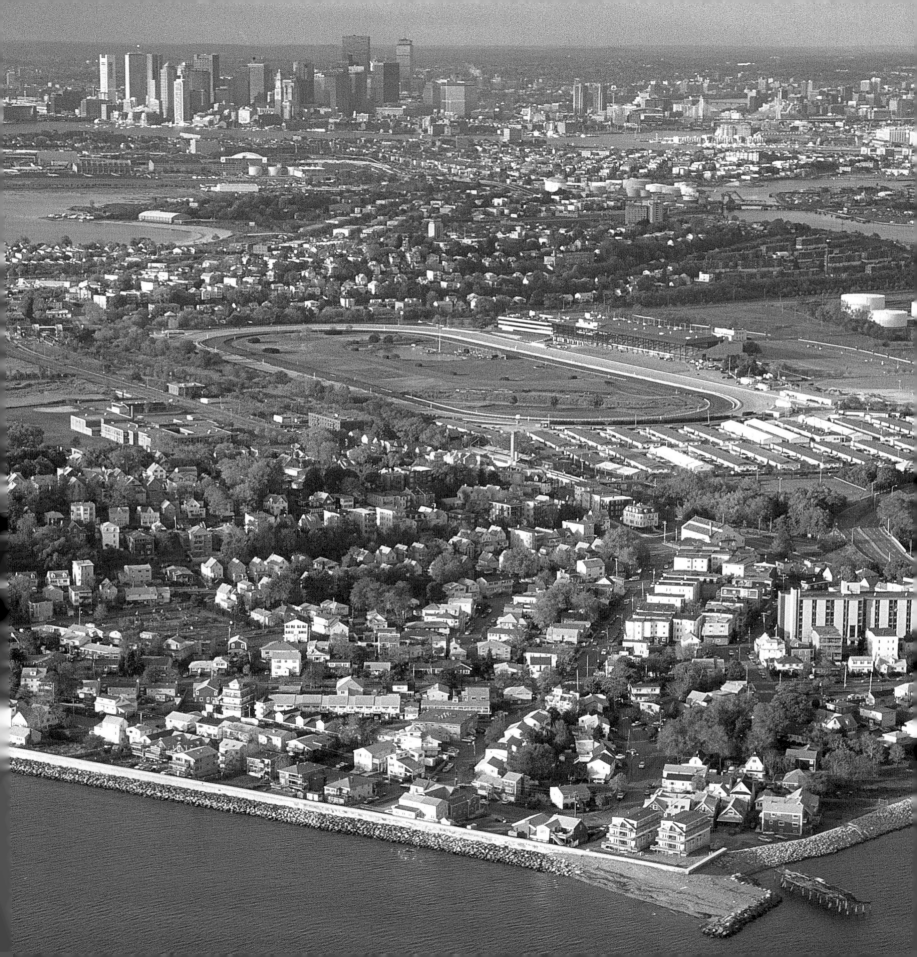

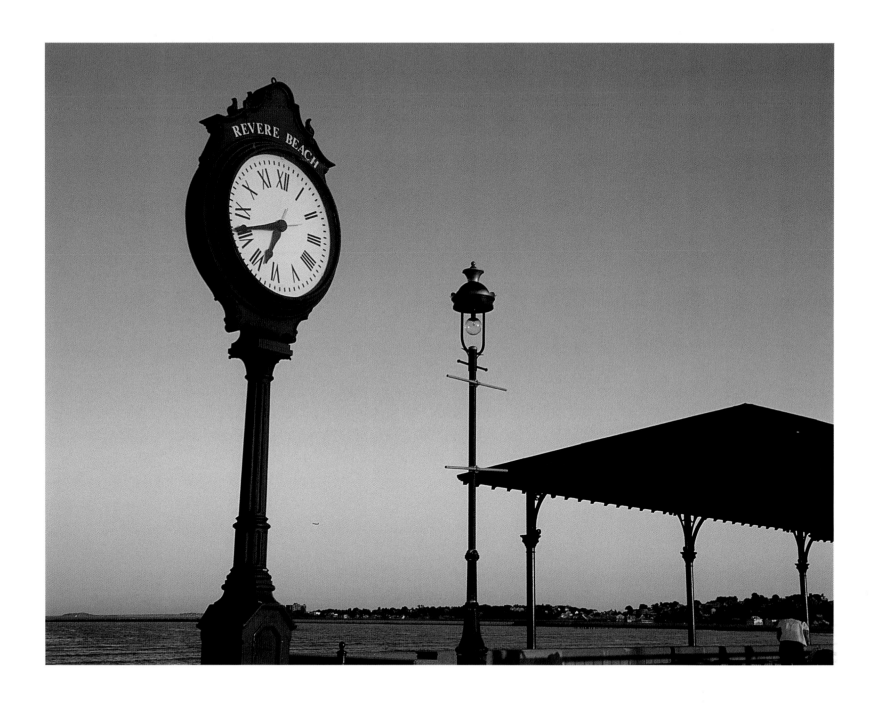

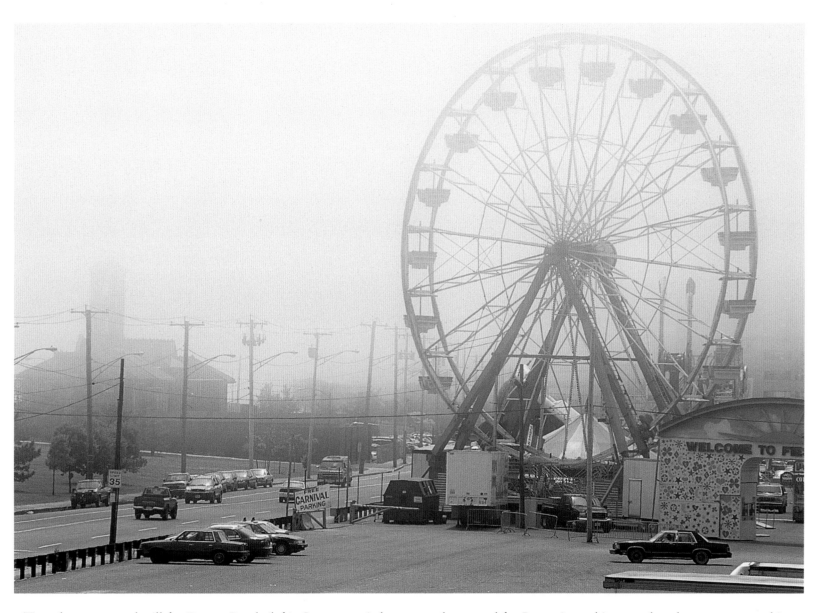

Time does not stand still for Revere Beach (left). Once a storied summer playground for Boston's working people, where a gut-wrenching rollercoaster ride sent screams toward the night sky, Revere Beach now hosts only the occasional traveling carnival. But the sky, the sand, and the sea still beckon, and the breeze works its cooling magic on hot summer days.

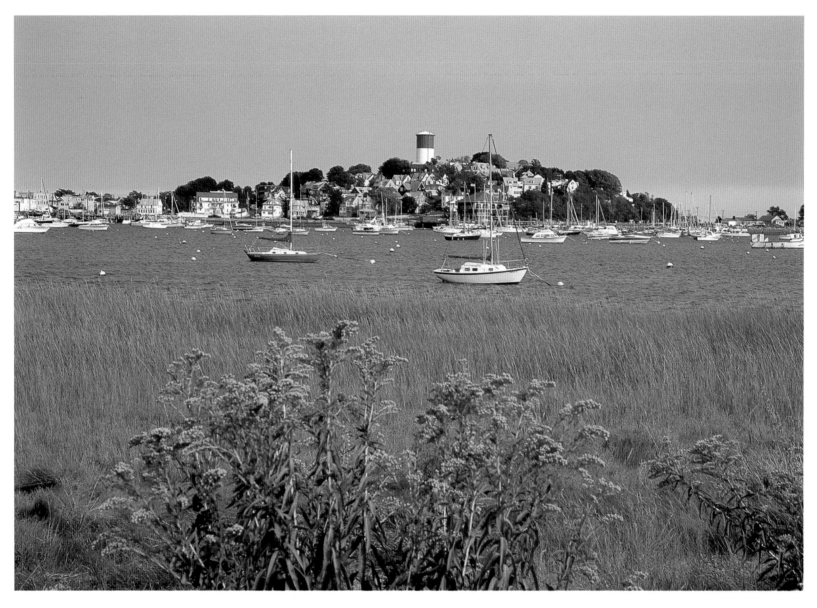

Like other communities extending from the North Shore—Nahant, Marblehead Neck, Eastern Point, Plum Island—Winthrop (above) is not on the way to anywhere. But once here, you'll find surprises—like the sixteenth-century Dean Winthrop House, the country's oldest wood frame house that has been continuously lived in (right). Winthrop is named for John Winthrop, one of the first governors of the Massachusetts Bay Colony. Dean Winthrop was his son.

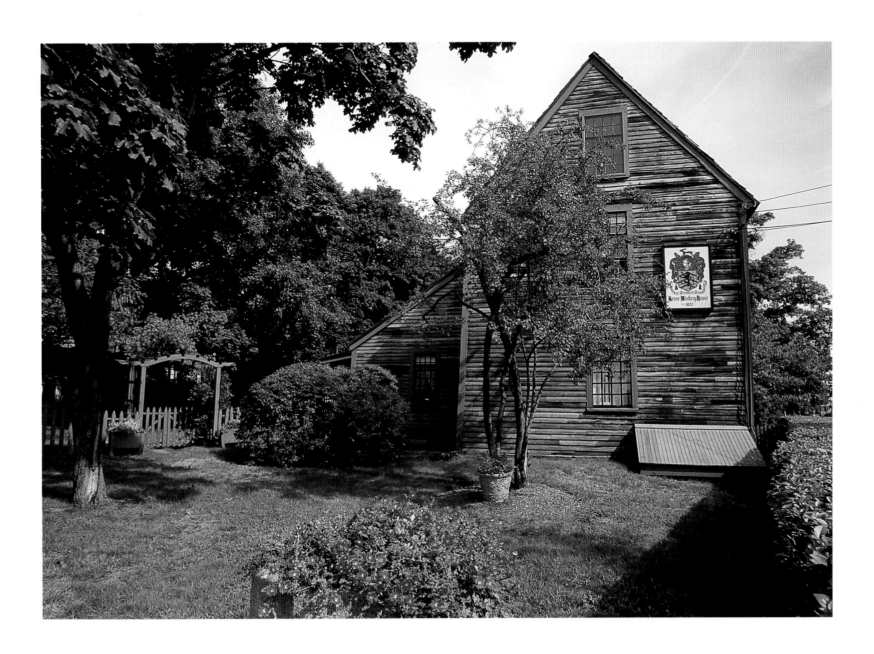

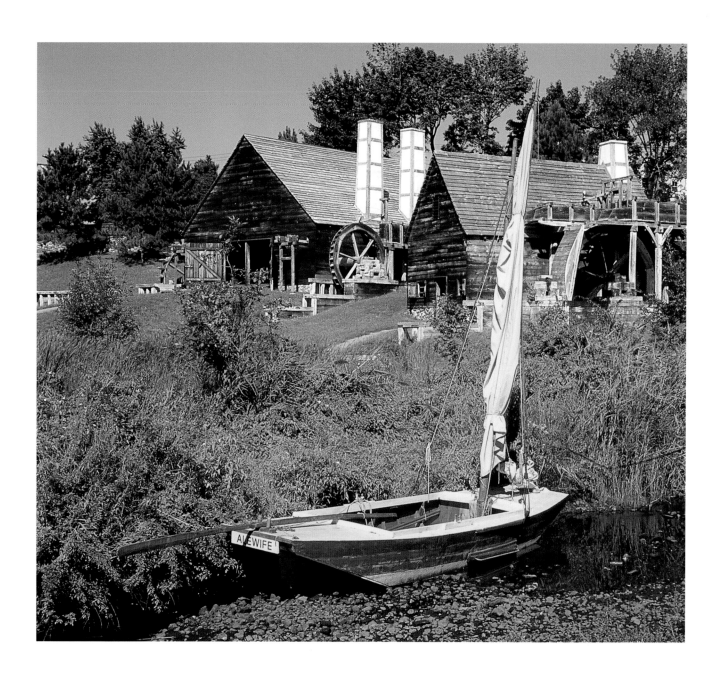

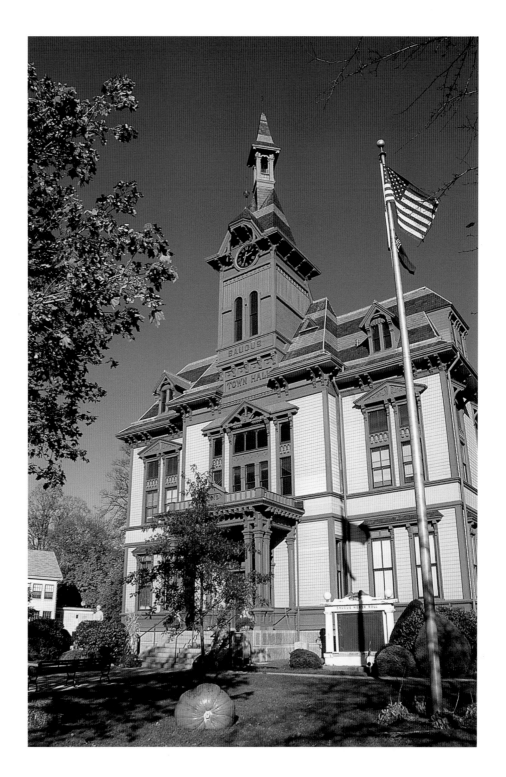

A period replica of the colonial lighter *Alewife*, a vessel used to transport iron along the Saugus River, floats before the Saugus Iron Works (left), site of the first viable iron-manufacturing operation in the country (1646). Once part of the city of Lynn, Saugus has its own proud history, as exemplified by its "High Victorian" Town Hall, restored in 1998.

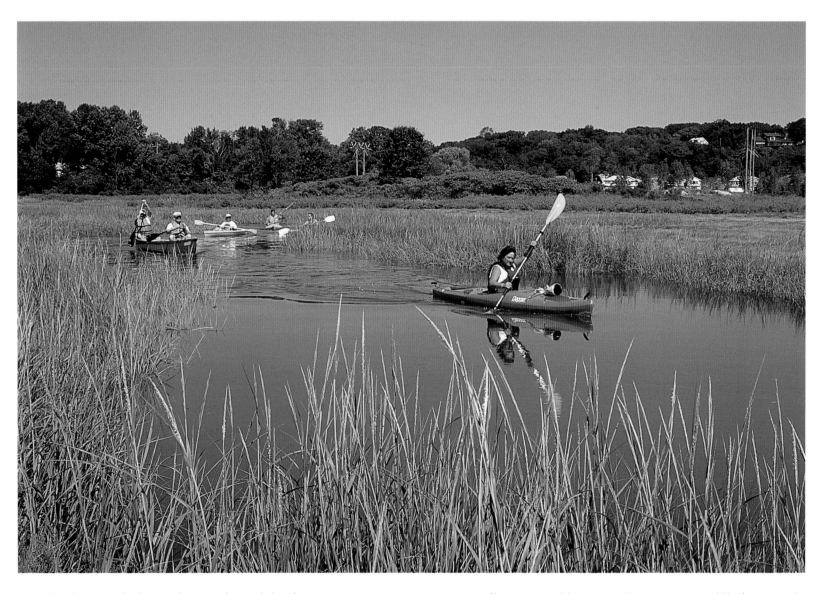

As elsewhere on the lower shore, industrial development gives way quite unexpectedly to natural beauty, and vice versa. Paddle far enough through Saugus (above) and you'll come upon the manufacturing plant known shorewide as "the GE" (right). The plant's owner, General Electric, dominated the regional economy for decades, much the way the plant still dominates the mouth of the Saugus River. Yet even here, in the lee of the smokestacks, lobster boats wait placidly for their next trip.

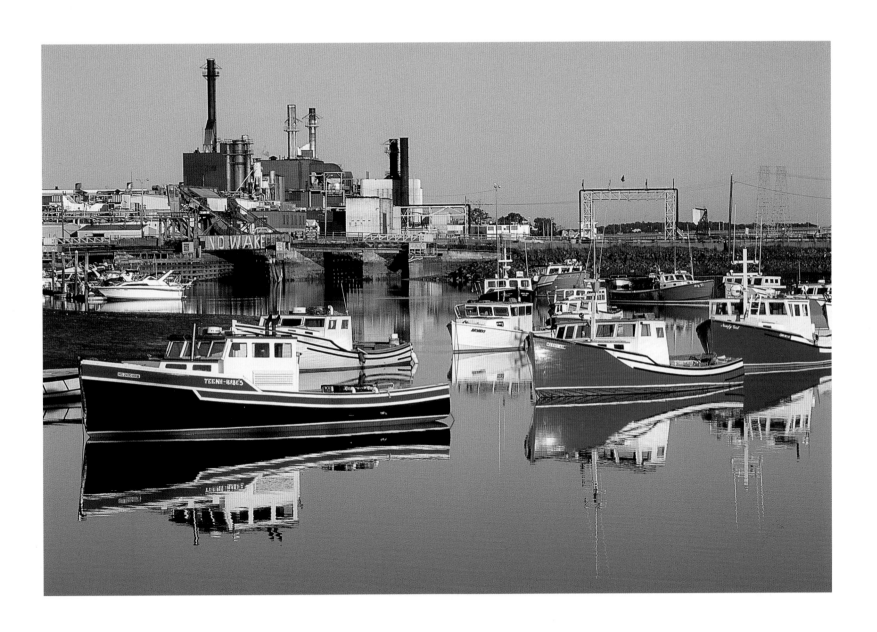

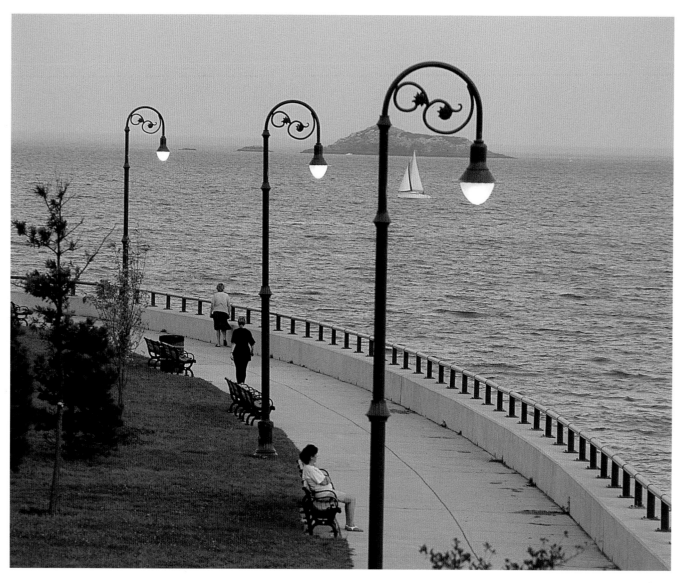

With Egg Rock looming in the distance, the promenade on Lynn Shore Drive is a cool respite on a summer's evening. But don't get too close to the breakwater when surf is crashing against it!

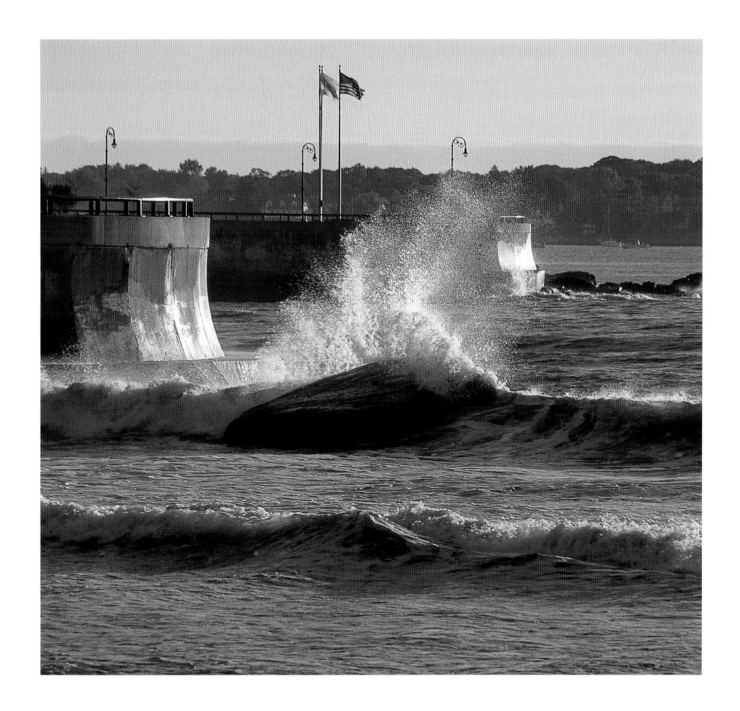

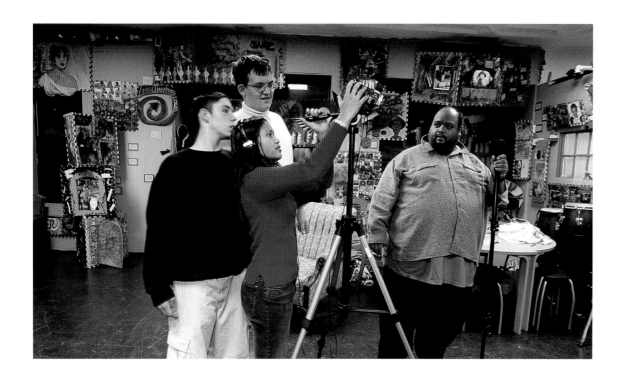

An exhibit at the Lynn Heritage State Park (right) recalls a time, in the nineteenth century, when Lynn was the country's shoe-making capital. A city that has rebounded from several setbacks, including a devastating 1889 fire, Lynn today is an active, diverse community. At RAW Art Works (above), an after-school group learns film-making. If artistic inspiration is what you're seeking, take a stroll through the Lynn Woods Reservation (far right).

14

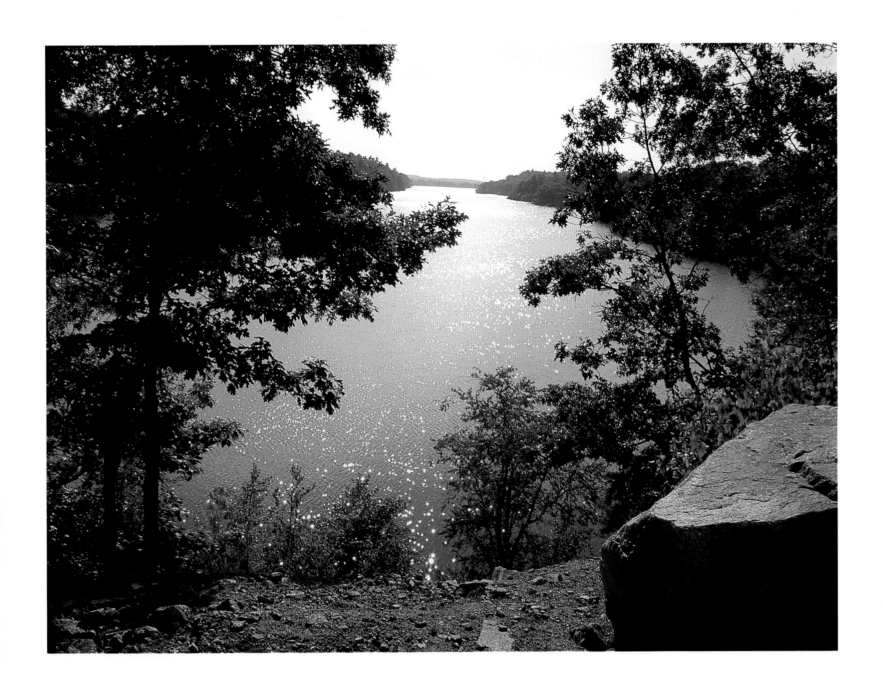

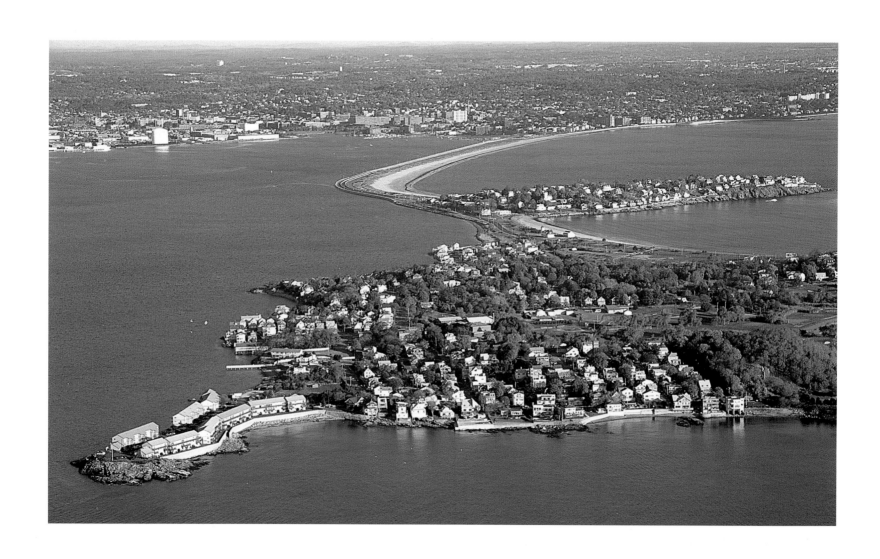

You can pick up speed on the causeway to Nahant and feel like you're skimming over the sound. Like other communities on the North Shore, Nahant has a small-town feeling, if town isn't too grandiose a word for a village that includes a police station, post office, general store, library, and little else. Each road ends in ocean, and many offer a magnificent view of the Boston skyline. At Northeastern University's Marine Science Center, Dr. Nathan W. "Doc" Riser (below center) studies green crabs with graduate students.

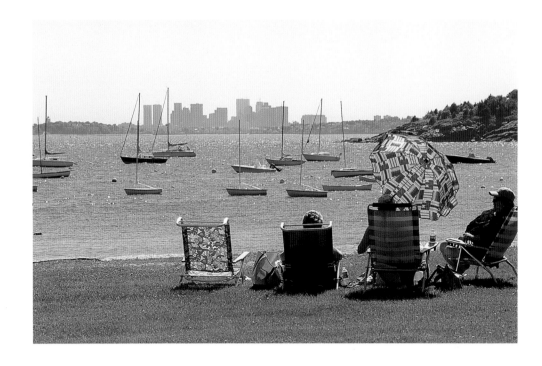

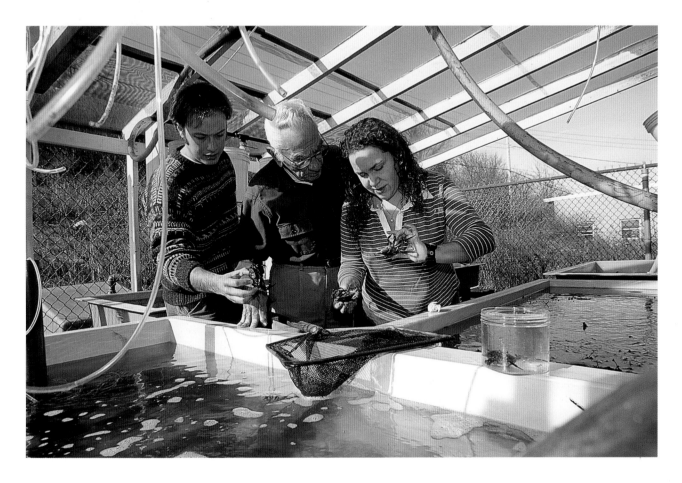

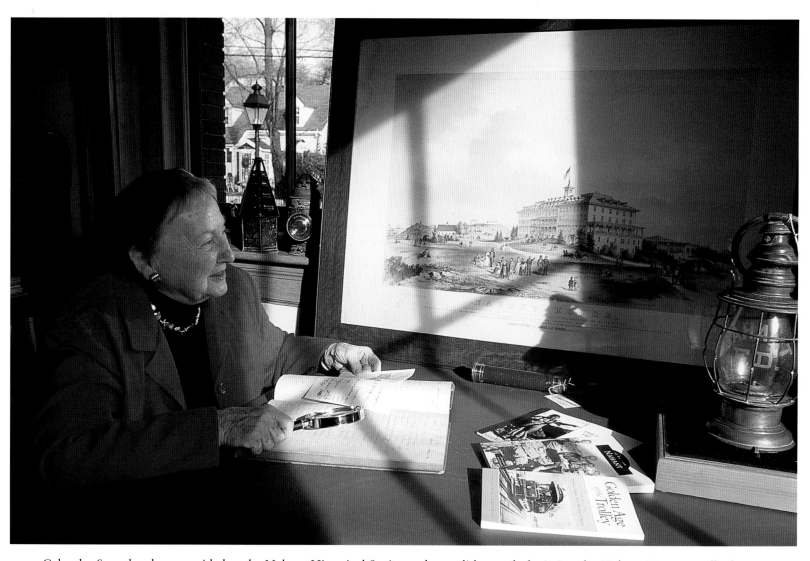

Calantha Sears has long presided at the Nahant Historical Society, where a lithograph depicting the Nahant House recalls the era when Nahant was the favored summer oasis of Boston's gentry. Along the coast in Swampscott, members of the Swampscott Club—a men's social club founded in 1893—enjoy a game of cards (right).

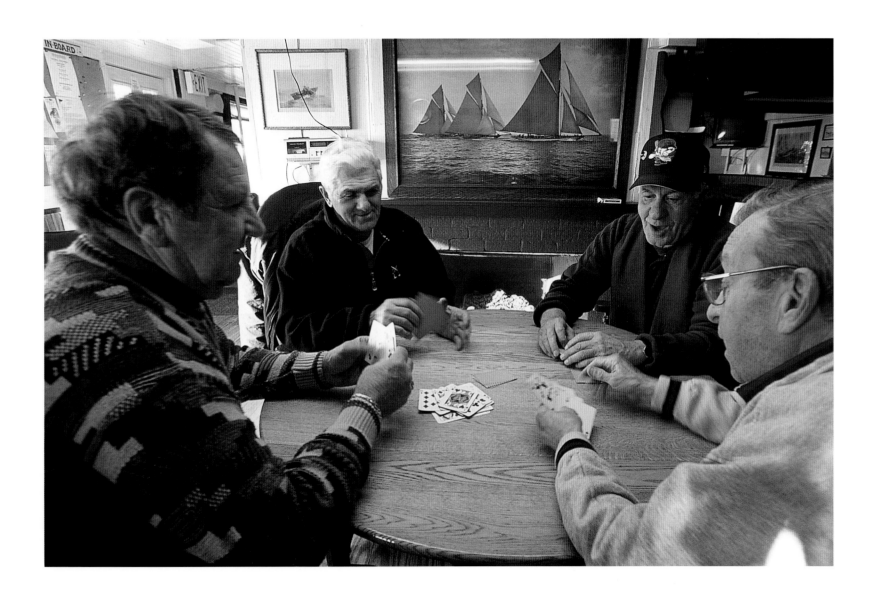

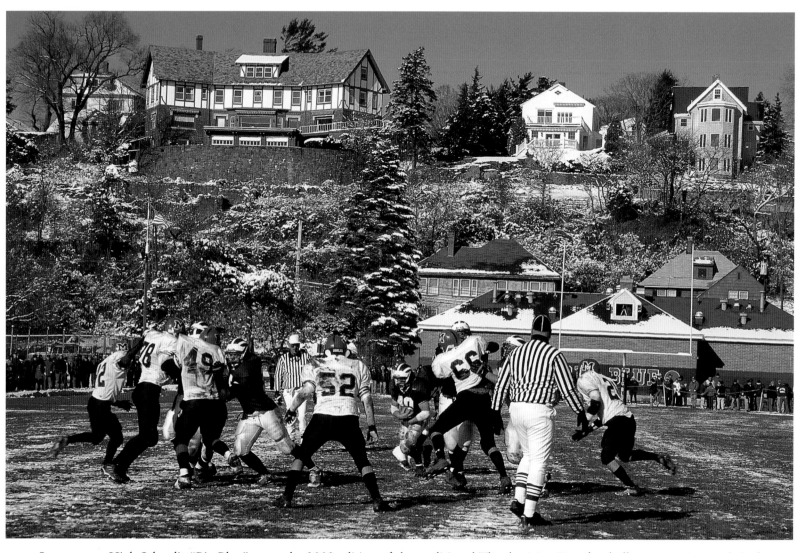

Swampscott High School's "Big Blue" won the 2002 edition of the traditional Thanksgiving Day football game against archrival Marblehead "Headers." On a hot summer's day at King's Beach in Swampscott, everyone's a winner.

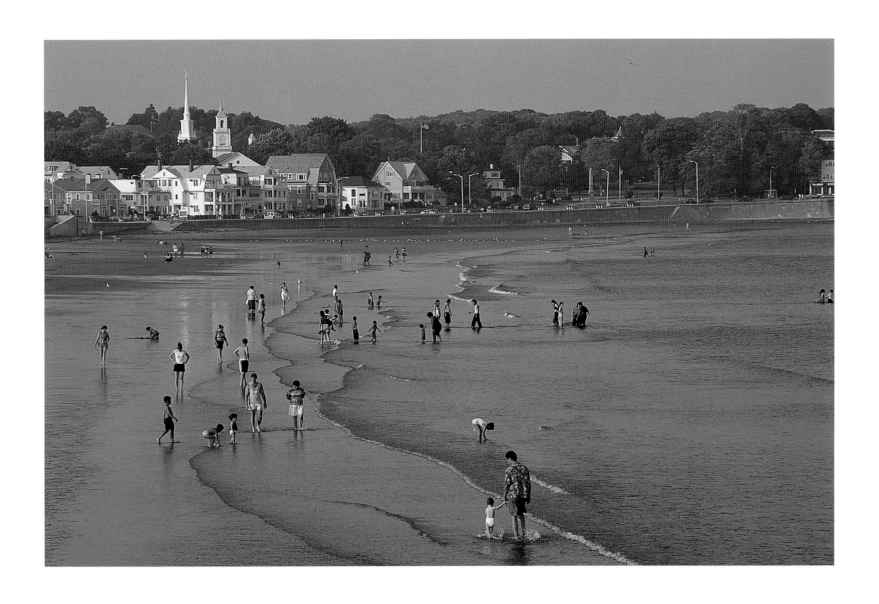

AROUND SALEM SOUND

Best known for the infamous witch trials of 1692, the city of Salem built its wealth and prestige on the maritime trade. A snow-swept statue of Salem's founder, Roger Conant (below), recalls the difficult conditions the first settlers faced in 1626. *Friendship*, a 171-foot reconstruction of a three-masted Salem East Indiaman that plied the oceans after the Revolution, greets visitors to the Salem Maritime National Historic Site (right).

Marblehead, Beverly, Danvers, and Peabody are outgrowths of Salem. Marblehead, with an undying reputation for eccentricity, was settled by fishermen who wouldn't heed the stern doctrines of Salem's Puritan ministry. Beverly was a Salem neighborhood until it became an independent community in 1668. Seventeenth-century Salem Village, home of Rebecca Nurse, the first woman accused of withcraft, is now Danvers. Peabody split off from Danvers in 1868 and now has twice the population of present-day Danvers.

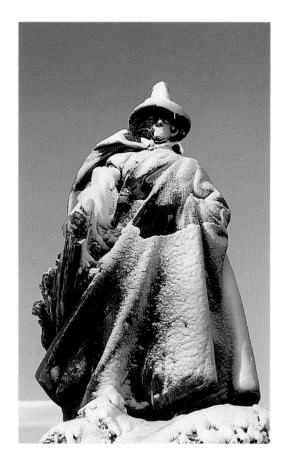

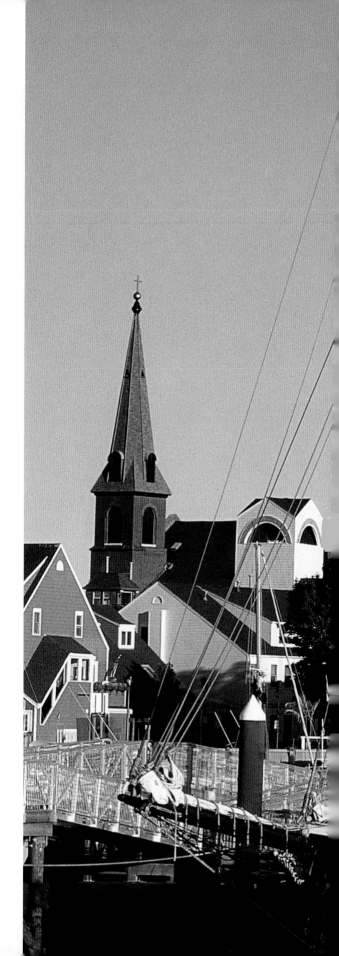

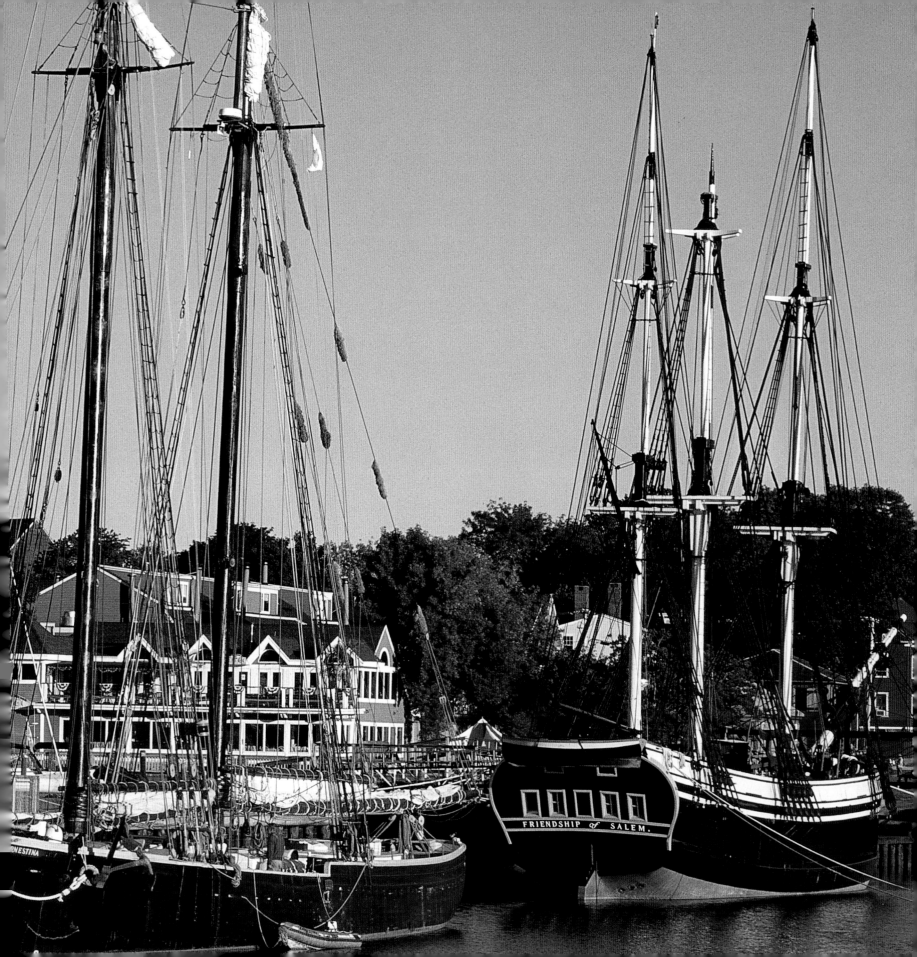

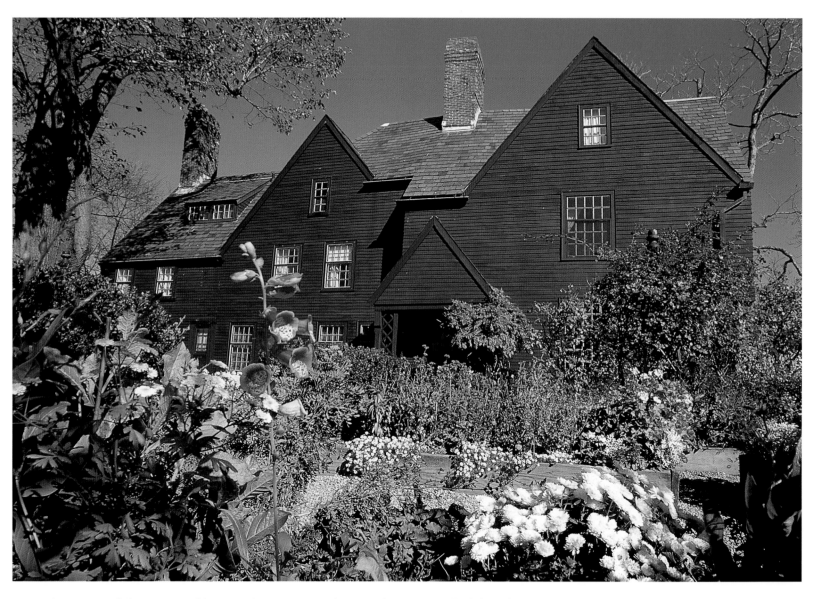

The House of the Seven Gables was the inspiration for Hawthorne's novel of the same name. That book recalls Salem's inglorious past as a place of persecution and guilt. This beautifully preserved landmark, like so much else in Salem and surrounding towns, has origins in the maritime trade. Before it was the home of a Hawthorne cousin, it was the seventeenth-century house of prosperous sea captain John Turner.

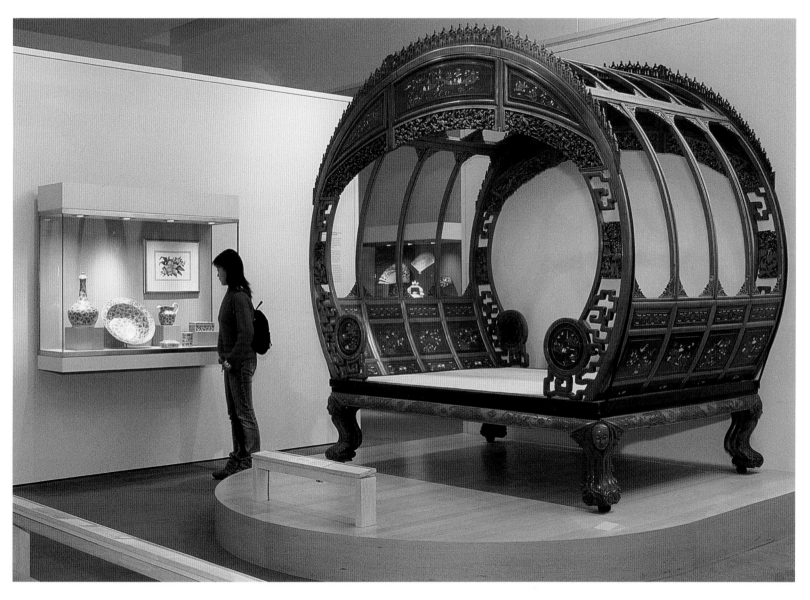

No place has preserved Salem's maritime past like the Peabody Essex Museum, which has become home to this Chinese "Moon Bed" and other artifacts of the China trade. Founded in 1799, the Peabody Essex is the oldest continuously operating museum in the country, founded in 1799.

Salem floods with visitors in October, when the city promotes "Haunted Happenings." A group of rapt visitors follows local historian Jim McAllister on the "Witch Trial Trail."

Celebrating the year-end holidays in a different light, the Paul Madore Chorale brings music to the First Church in Salem, the oldest Protestant church gathered in North America.

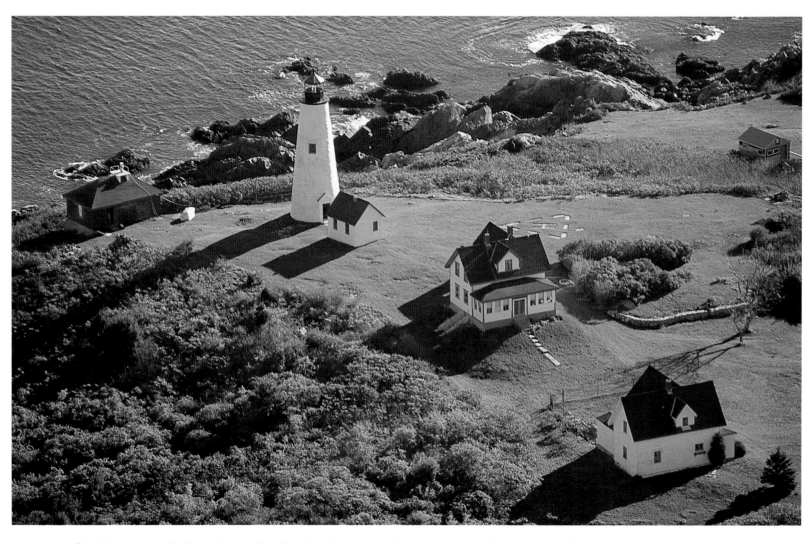

A ring of lighthouses, including Baker's Island Light (above), stand sentry around Salem Sound. There once were two lights on Baker's, to go with the those of Marblehead, Winter Island and Derby Wharf in Salem, and Hospital Point in Beverly.

Salem's community is now more diverse than at any time in its history, as a pickup basketball game on the historic town common (above) attests. For younger players, few games are more enticing than the arcade at Salem Willows (right). All those tickets may not buy you much, but they represent a whole evening of fun.

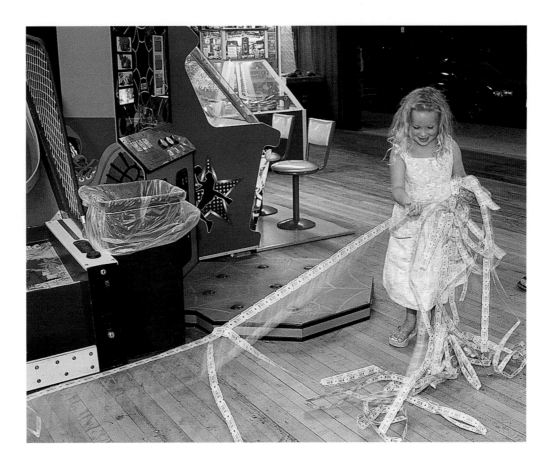

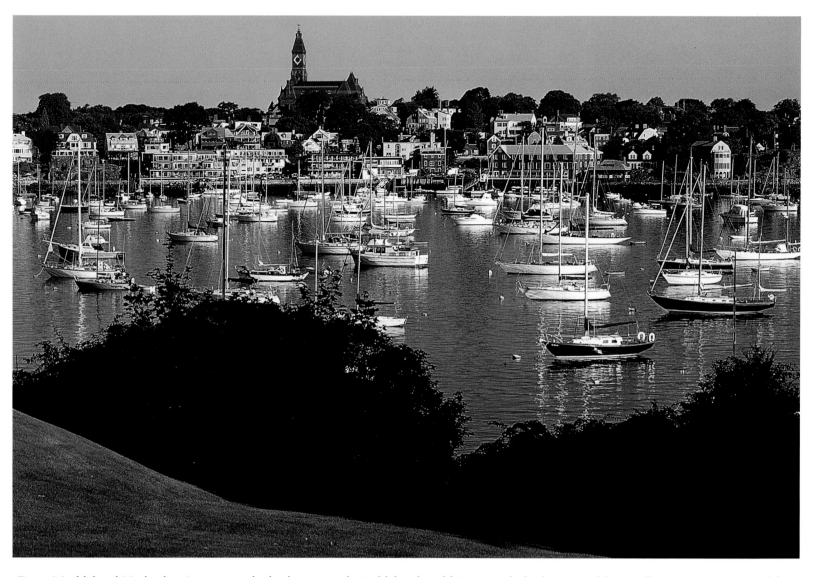

From Marblehead Neck, the view across the harbor toward Marblehead's Old Town includes historic Abbot Hall, a Victorian brick edifice that serves as Marblehead's seat of government. Here Archibald Willard's famed painting *The Spirit of '76* is on display.

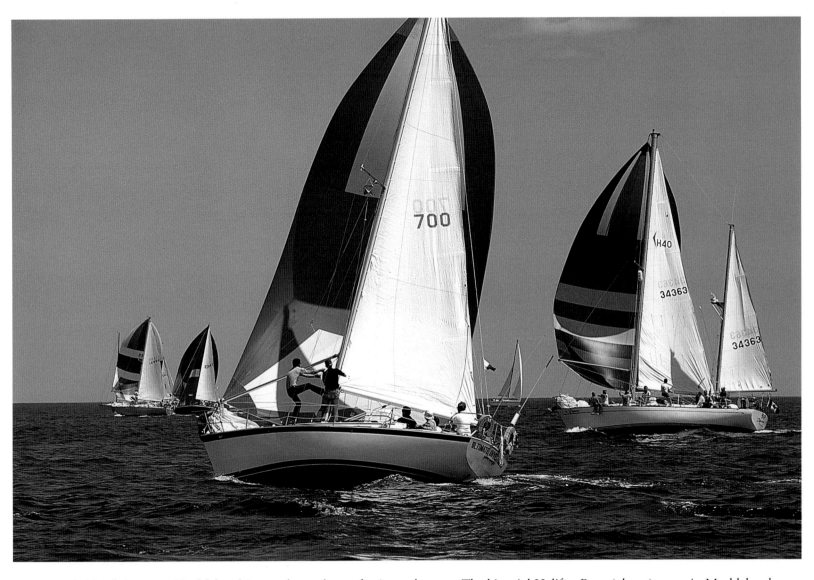

Founded by fishermen, Marblehead is now better know for its yachtsmen. The biennial Halifax Race (above) starts in Marblehead, sending intrepid sailors down east to the capital of Nova Scotia.

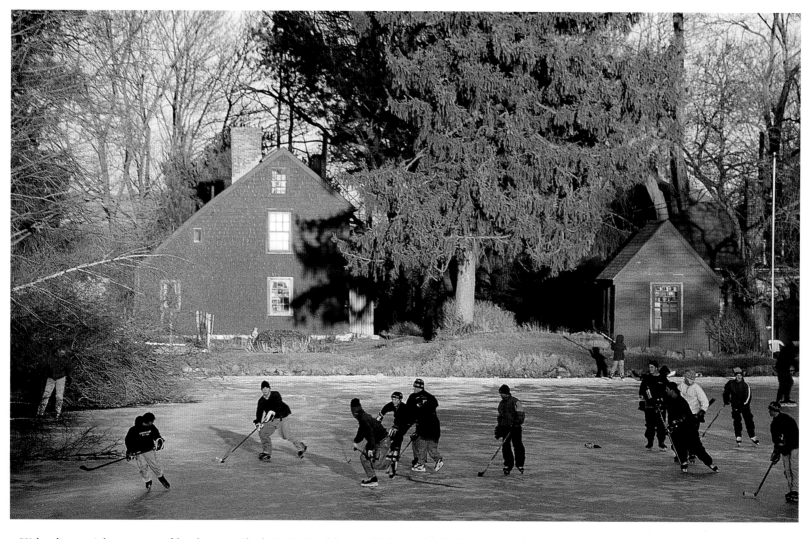

Kids play a pickup game of hockey on Black Joe's Pond in Marblehead. In the background is Black Joe's Tavern, a popular watering hole around 1800. A winter view from the tower of Abbot Hall (right) shows off the crookedness of Marblehead's streets.

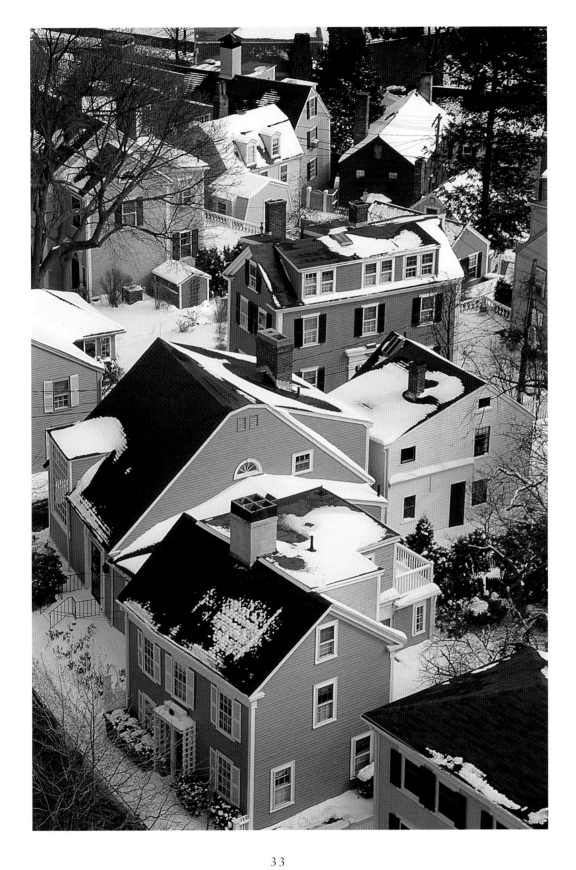

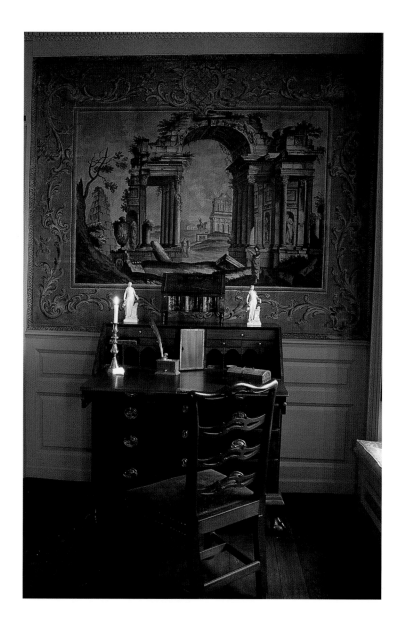

The Jeremiah Lee Mansion in Marblehead (left) is a wonderful example of pre-Revolutionary Georgian architecture. The wallpaper was handpainted in England. The Marblehead Little Theater (below) offers another English artifact, Dickens's story of *Oliver Twist* in the musical adaptation *Oliver!*

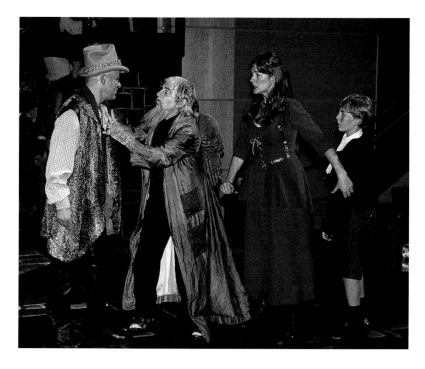

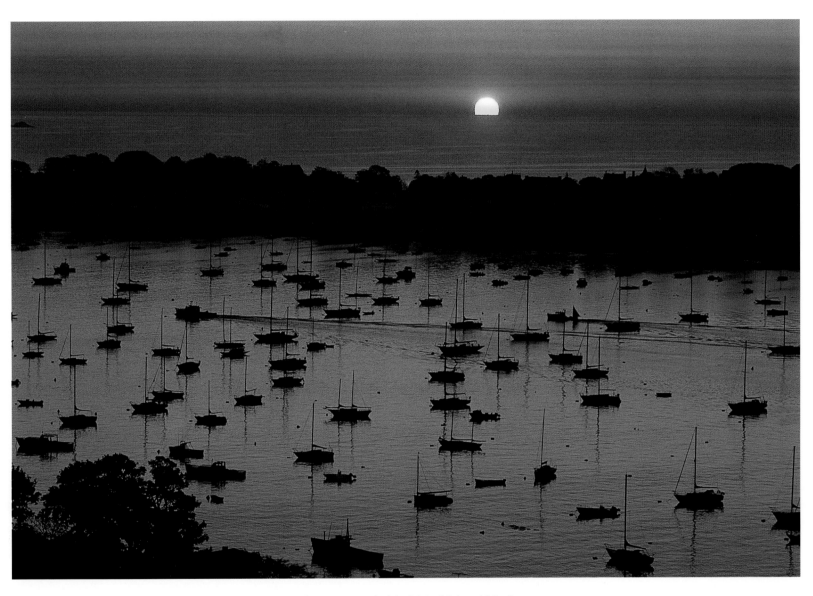

The sun rises behind Marblehead Neck.

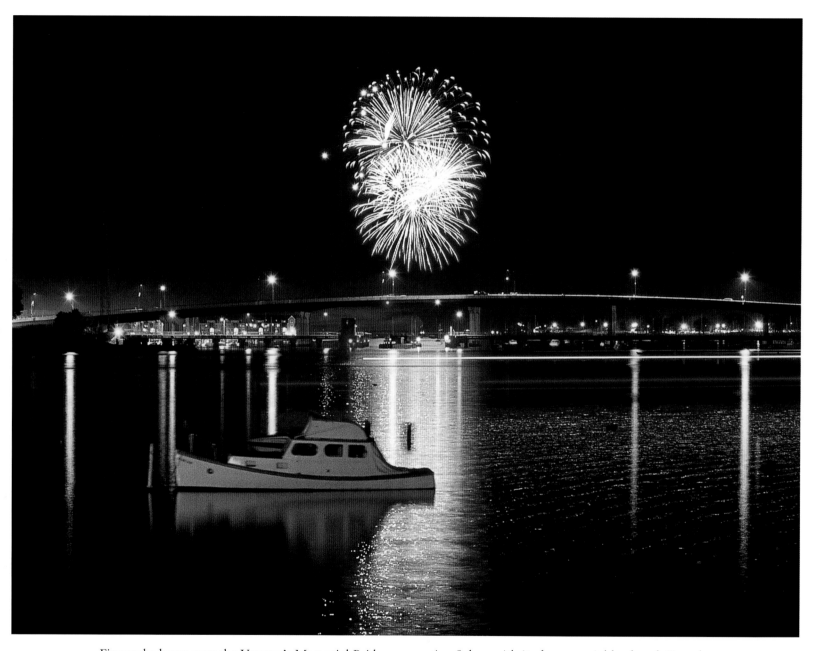

Fireworks burst over the Veteran's Memorial Bridge connecting Salem with its former neighborhood, Beverly.

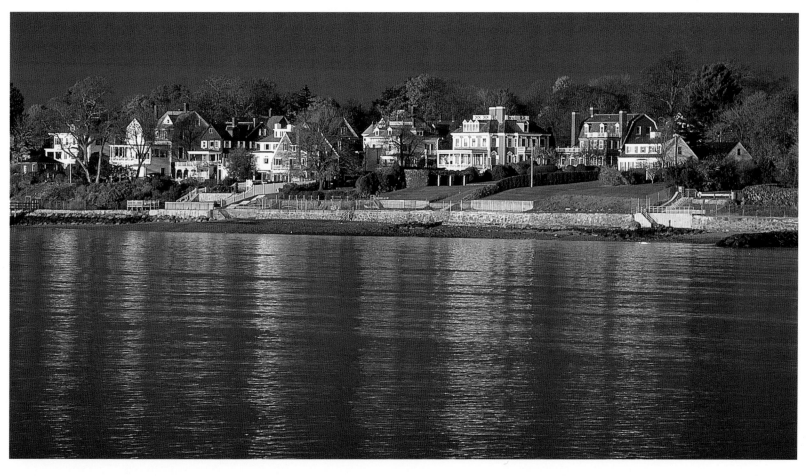

Beverly has eight beaches, most of them open to the public, and miles upon miles of water frontage. It's no wonder that, beginning in the 1840s, many wealthy Boston families built their summer homes here, and farther up the shore.

The focal point of Beverly's Homecoming Week in early August, Lynch Park features a glorious rose garden, outdoor band concerts, and a lively playground. The summer home of President William Howard Taft once stood on these grounds. Hospital Point Light (right) guards the entrance to the harbor. By lining it up with the beacon in Beverly's First Baptist Church, night sailors can follow the channel to safe harbor.

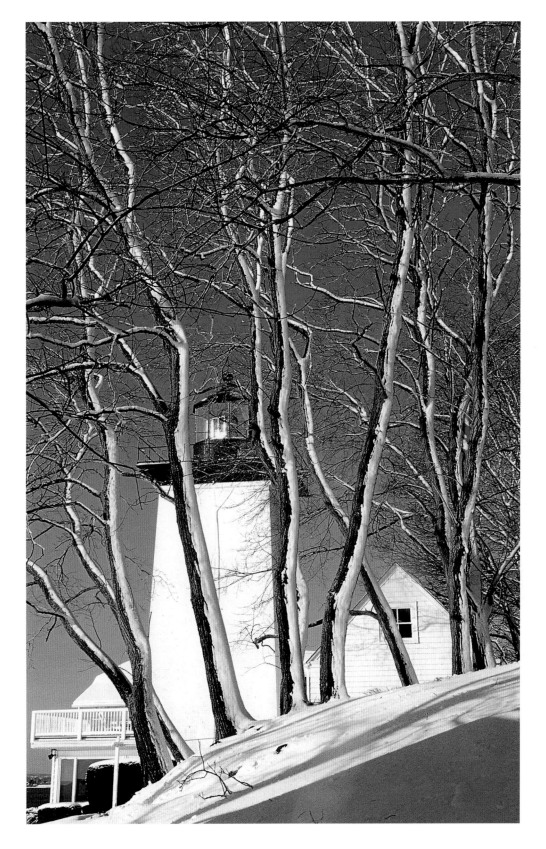

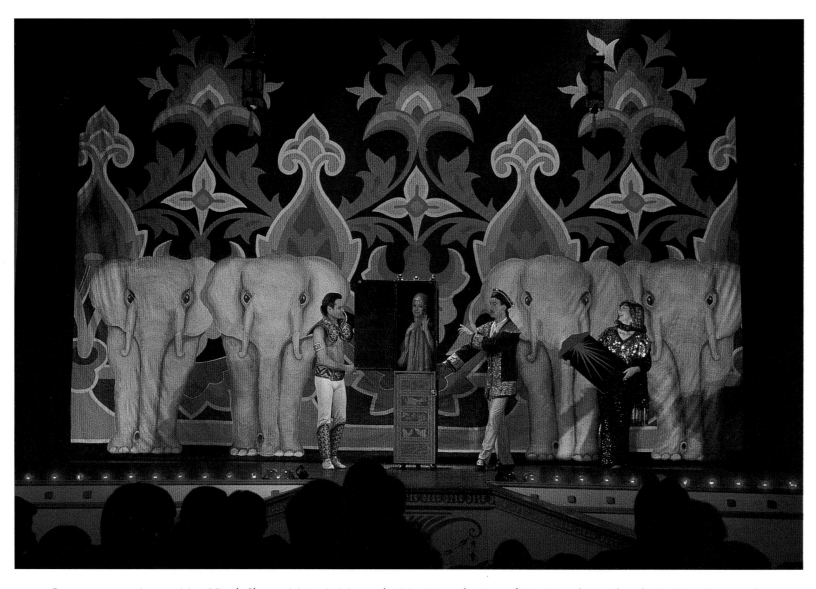

One more surprise awaiting North Shore visitors is Marco the Magi's production of "Le Grand David and His Own Spectacular Magic Company," a turn-of-the-last-century-style stage extravaganza that has been in residence at Beverly's Cabot Street Cinema Theatre for over a quarter of a century.

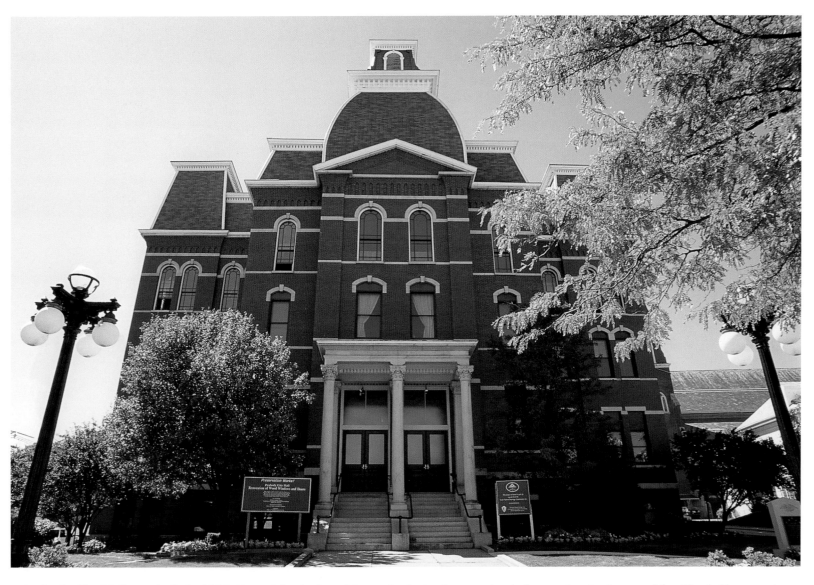

Peabody City Hall was built in 1883. Famed for its long history in the leather-tanning industry, the city is named for North Shore native George Peabody, founder of the Morgan Bank. In his later years, the great financier was a benefactor of libraries in Danvers and Peabody and of the Peabody Museum in Salem, now the Peabody Essex Museum.

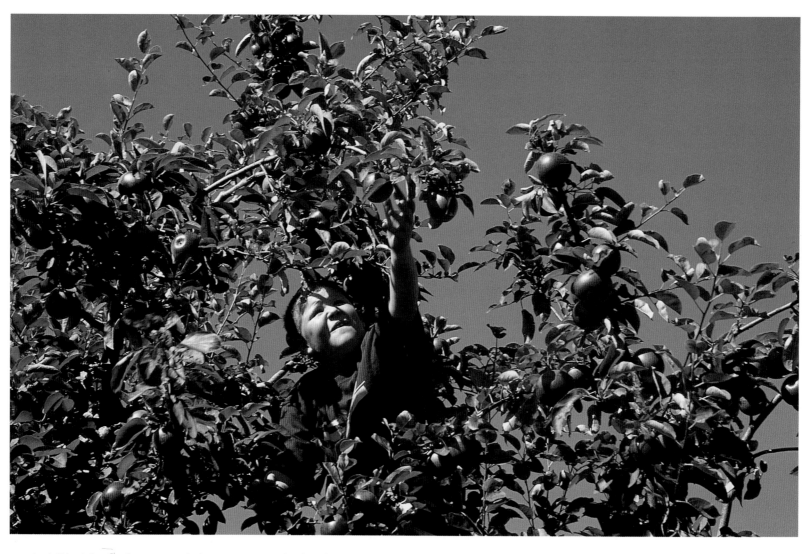

A child picks apples at Brooksby Farm in Peabody (above), while an organic farmer shows off his winter beets at a "Victory Garden" in Danvers's Endicott Park (right). From here northward, the shore boasts many working farms, harking back to a world three hundred years past.

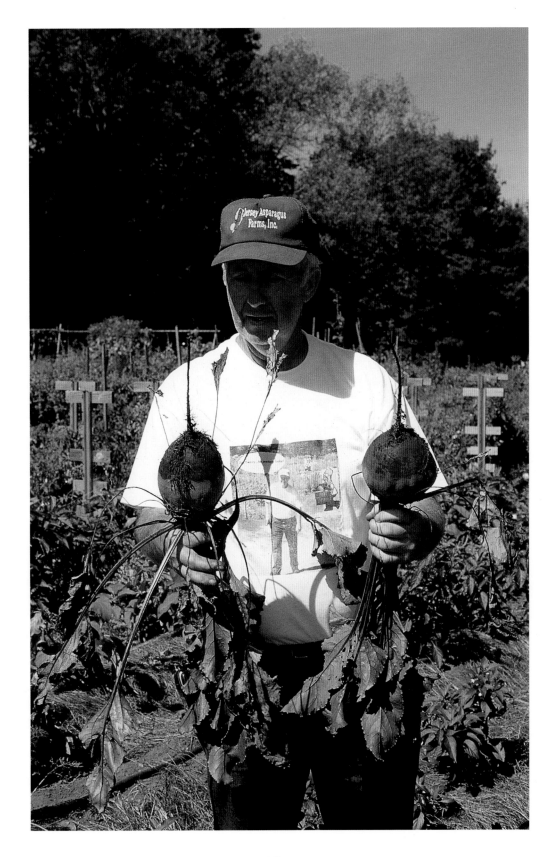

43

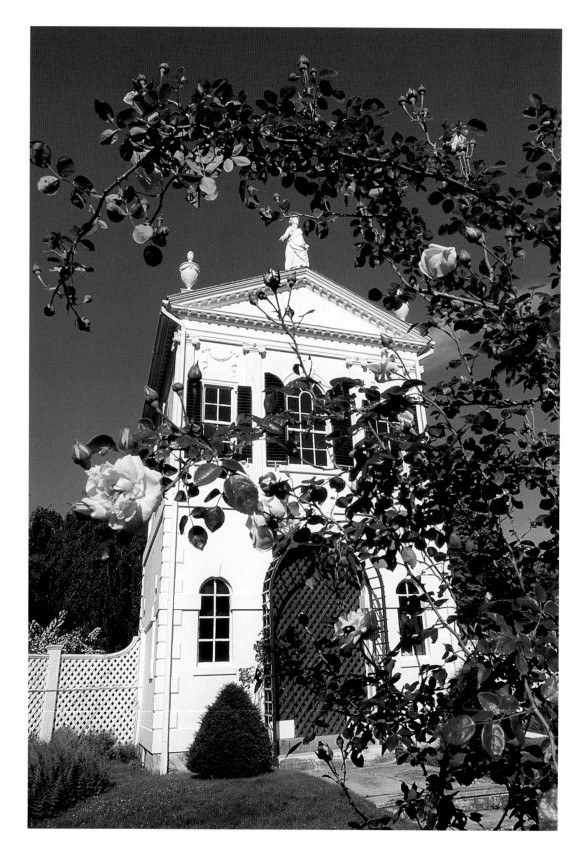

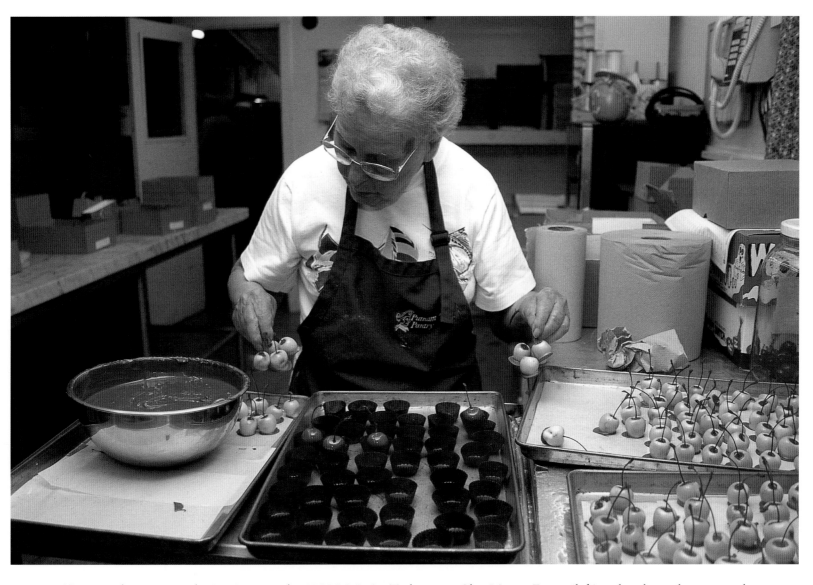

Two popular Danvers destinations are the 1793 McIntire Teahouse at Glen Magna Farms (left) and a place where tea and plenty of other treats are still served, Putnam Pantry (above).

Another reminder of the North Shore's agrarian past is the Essex Agricultural and Technical High School in Hathorne (Danvers), better known as Essex Aggie. The high school provides extensive training in agricultural and environmental sciences.

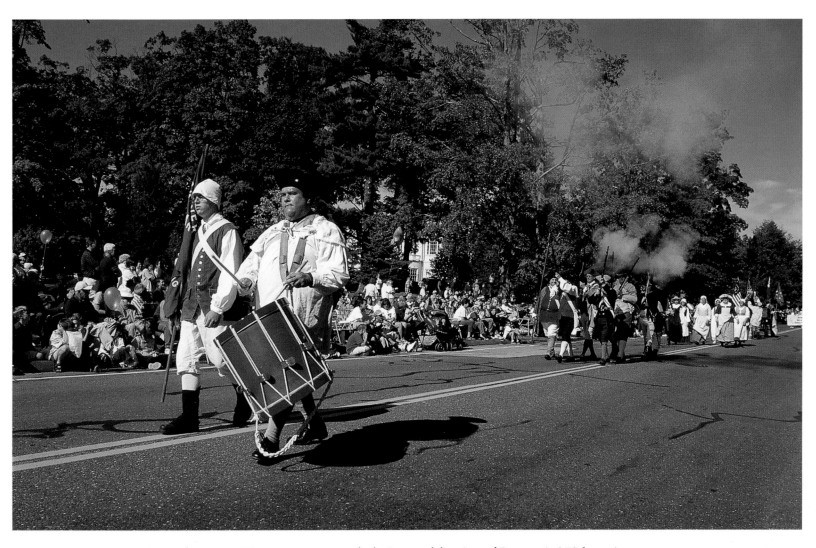

Revolutionary War reenactors march during a celebration of Danvers's 250th anniversary.

INTO THE WOODS

Why the landlocked communities of Wenham, Hamilton, Topsfield, and Boxford are considered part and parcel of the North Shore is anybody's guess, but they are. Though they're well forested, you'd hardly call them backwoods communities. In fact, they're well enough heeled to call themselves whatever they please. In these wooded towns, stands of trees replace the masts of pleasure boats, and the equestrian takes over from the yachtsman.

Like Beverly, its neighbor to the south, Wenham was once a borough of Salem, but it is now inextricably linked with Hamilton, its neighbor to the north. Hamilton is most associated with horse shows (below) and polo matches (right) in the vicinity of the exclusive Myopia Hunt Club, but it also bears the influence of a nineteenth-century evangelical community and a hard-as-nails twentieth-century general.

Farther into the woods, Topsfield features the oldest continuously operating agricultural fair in America, the Topsfield Fair, and an abundance of preserved landscapes, including Bradley Palmer State Park and the Audubon Society's Ipswich River Wildlife Sanctuary. In Boxford the air is so fresh that a town doctor of the nineteenth century said he "might as well practice in heaven."

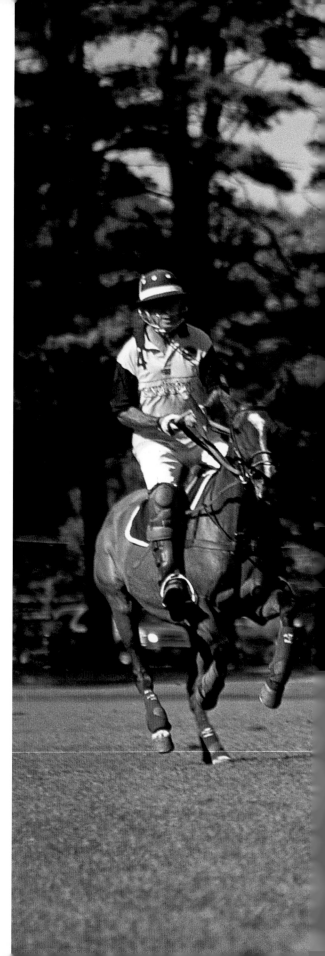

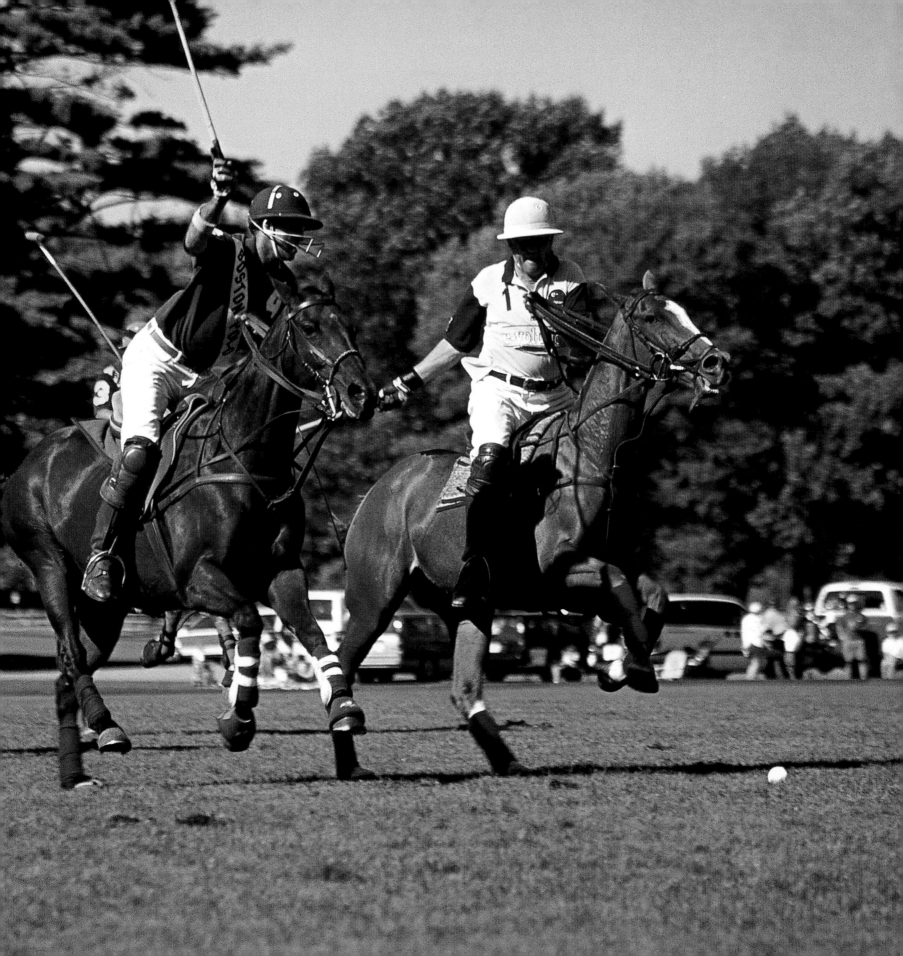

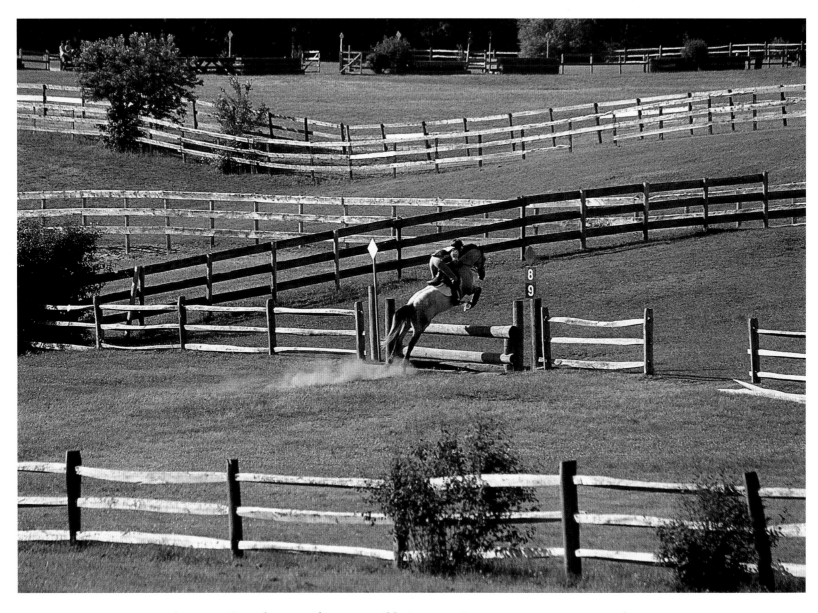

An equestrian takes one of many possible jumps at Groton House Farm in Hamilton.

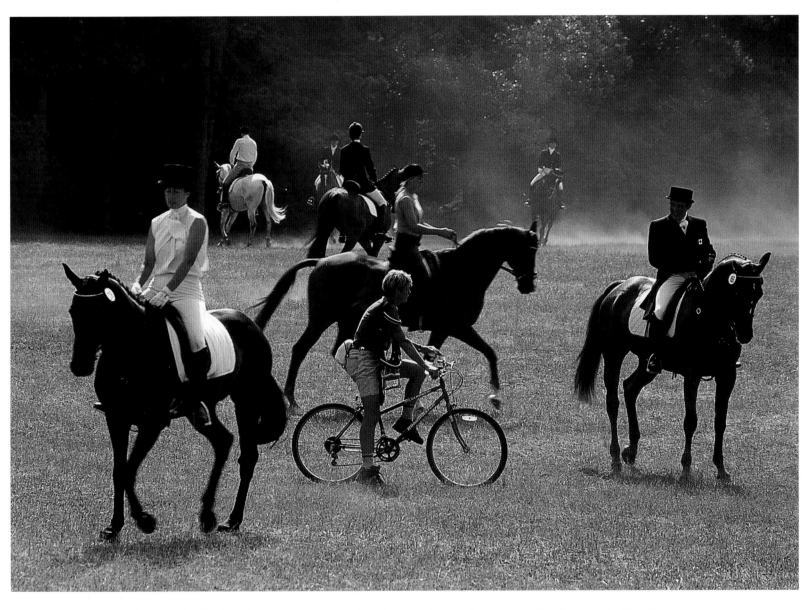

A two-wheeler is quite at home among four-leggers during the warmup for dressage in Hamilton.

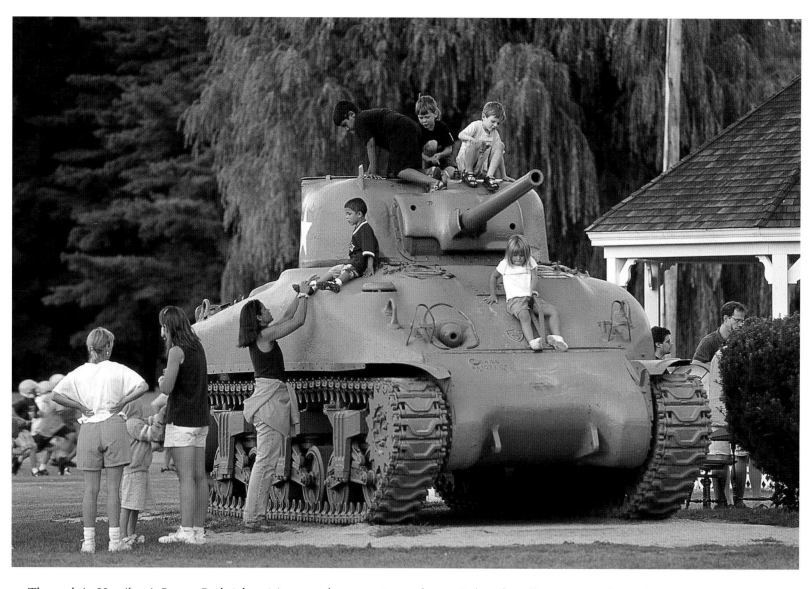

The tank in Hamilton's Patton Park (above) is a popular attraction and a reminder of an illustrious resident, Gen. George S. Patton, Jr. One of America's most esteemed doll collections, at the Wenham Museum (right), appeals to a different child.

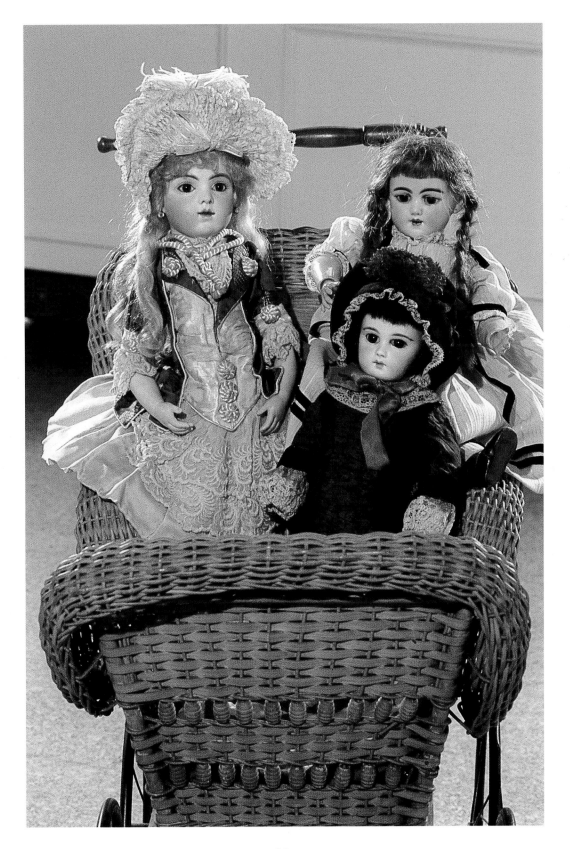

Inspiration comes in all shapes and sizes. One of the cottages at Asbury Grove, a religious campground in South Hamilton, is something out of a fairy tale (above), while the Congregational Church in Topsfield (right) is a more typical New England place of worship.

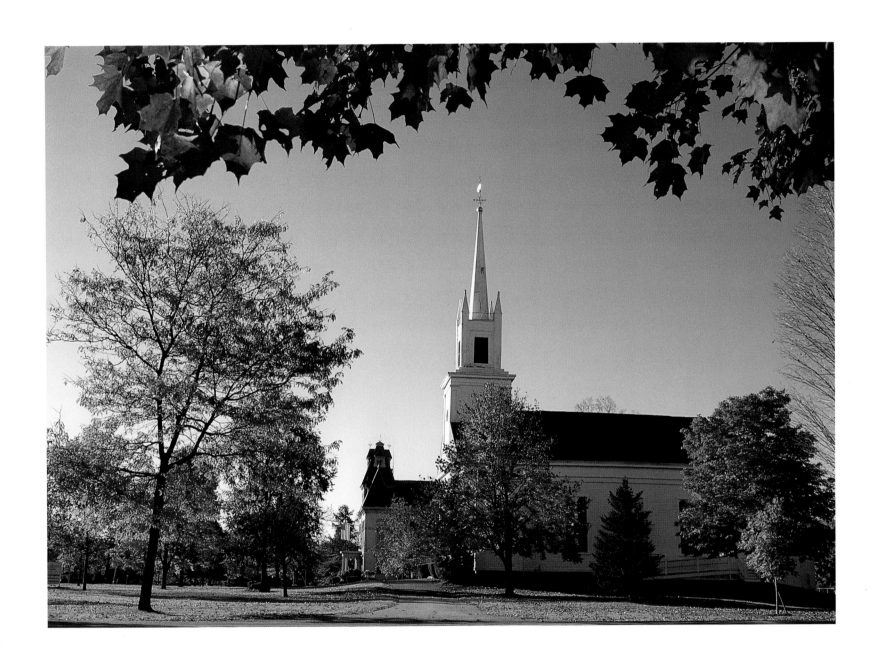

The Topsfield Fair, begun in 1818, is quite simply the North Shore's oldest and favorite family attraction.

The ice-shrouded waters of Ipswich River flow through Bradley Palmer State Park in Topsfield.

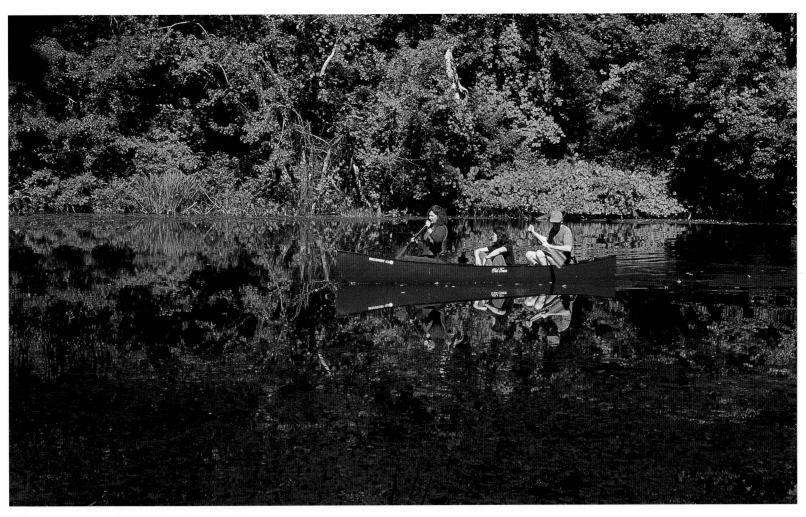

In a warmer season, a canoe navigates another stretch of the Ipswich River.

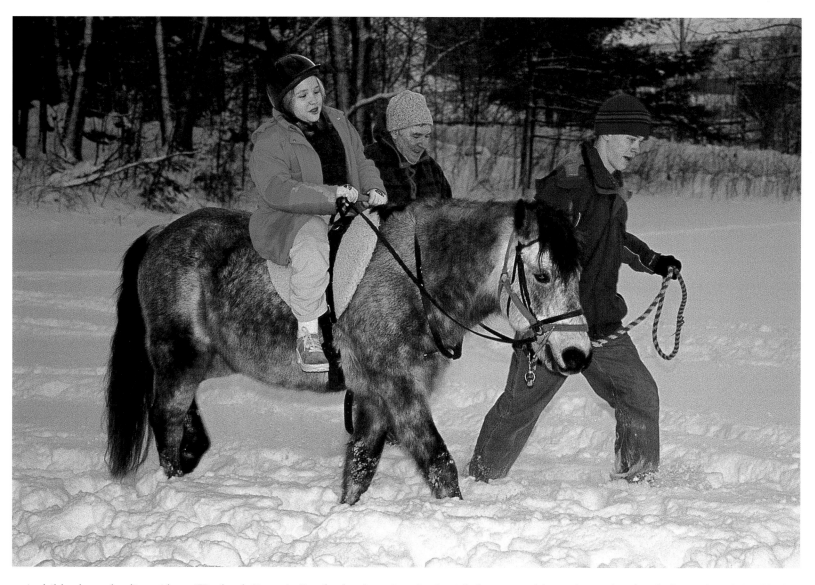

A child takes a healing ride at Windrush Farm in Boxford, where "equitation" helps expand boundaries for the challenged and disabled.

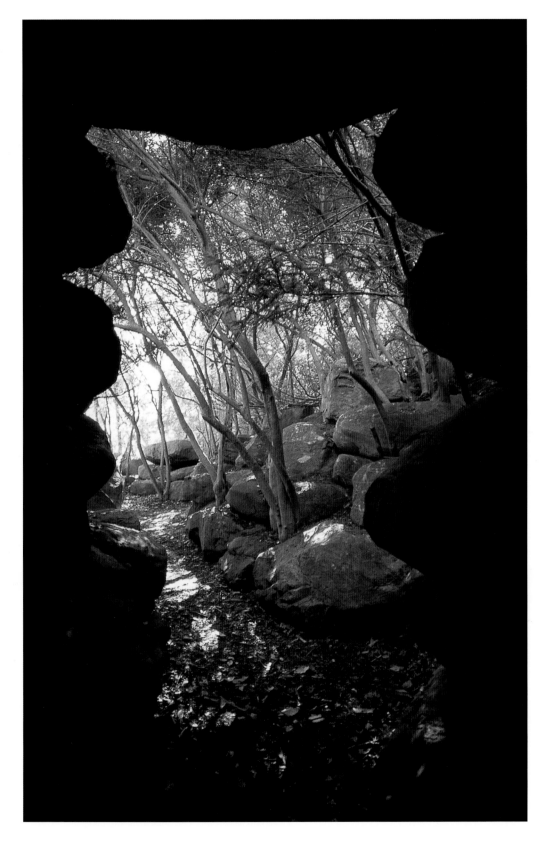

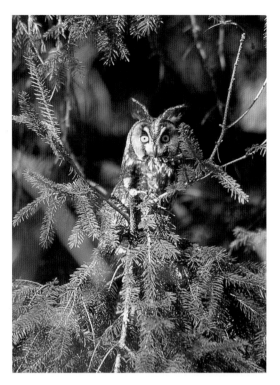

It's an enchanted view (below) from inside the Rockery at the Massachusetts Audubon Society's Ipswich River Wildlife Sanctuary in Topsfield. And a great horned owl (right) may be watching from just outside.

AROUND CAPE ANN

The evening commuter train leaves the Beverly Farms depot (below) and heads northeast to Cape Ann—a promontory less prominent but far more rock-ribbed than sandy Cape Cod. It was here, on the shoals off Magnolia, that the *Hesperus* wrecked, here too, in Rockport, that granite has been a way of life.

Though there are no farms to speak of in Beverly Farms, there are estates aplenty—here and up the coast in Manchester-by-the-Sea (right). When Boston Brahmins tired of Nahant, they moved to this so-called "Gold Coast" in the mid-nineteenth century, and their descendants still partake of the best ocean views. The greatest castle on this stretch of shore is farther up the coast in Magnolia, where the eccentric inventor John Hays Hammond built his.

Cape Ann is a study in contrasts: the briny fish smell of Gloucester with the aroma of roses behind Rockport's picket fences, the hard ledges of Gloucester and Rockport with the tidewashed marshlands of Annisquam and Essex. This is, by turns, fish country, quarry country, clam country—all of it admired and captured, at one time or another, by some of America's greatest painters, from Fitz Hugh Lane and Winslow Homer to the thriving colony of latter-day impressionists in Rockport today.

The focal point of Cape Ann, for all that, is Gloucester, a city so rich in history and heart that it deserves a poet, and has had several—from Rudyard Kipling and James B. Connolly to Sebastian Junger, Vincent Ferrini, and the dean of today's Cape Ann writers, Joe Garland.

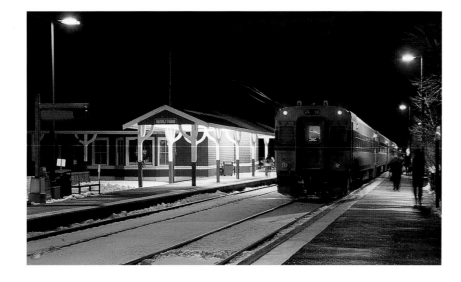

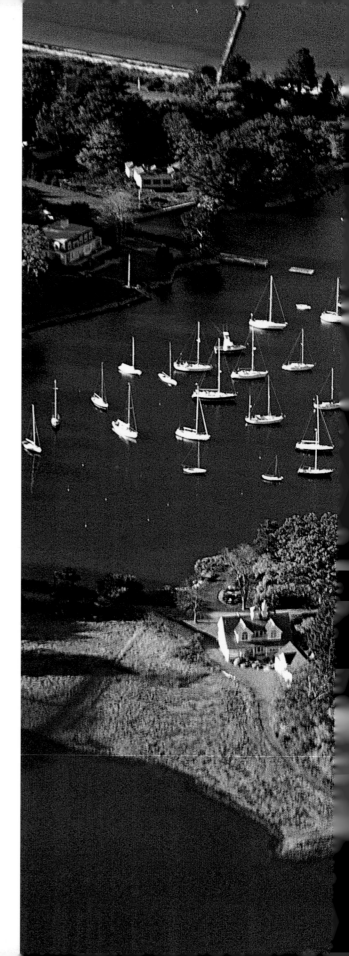

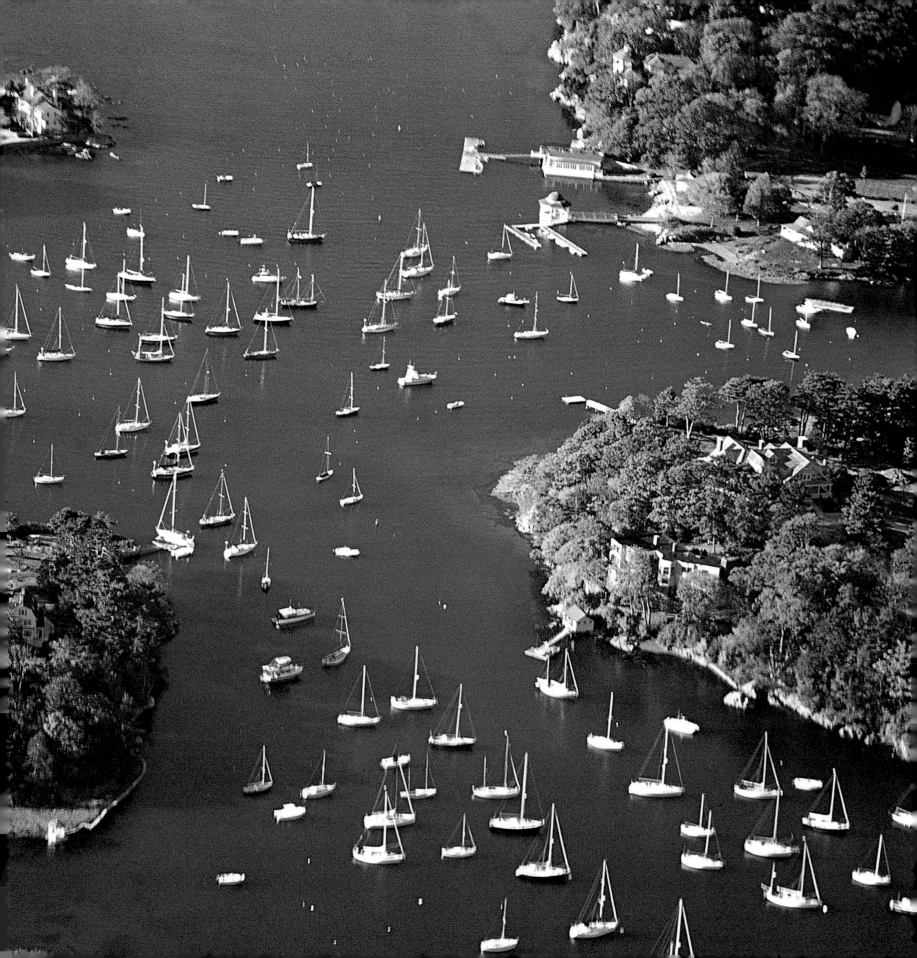

This is what summer on the North Shore is all about—gazing dreamily at sailboats swaying at anchor in Manchester harbor (above), or looking east (right) from a beach that "sings."

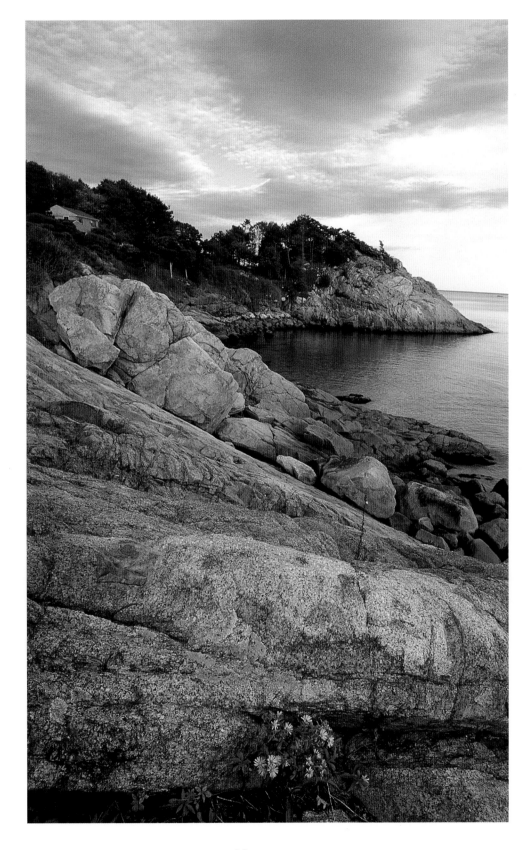

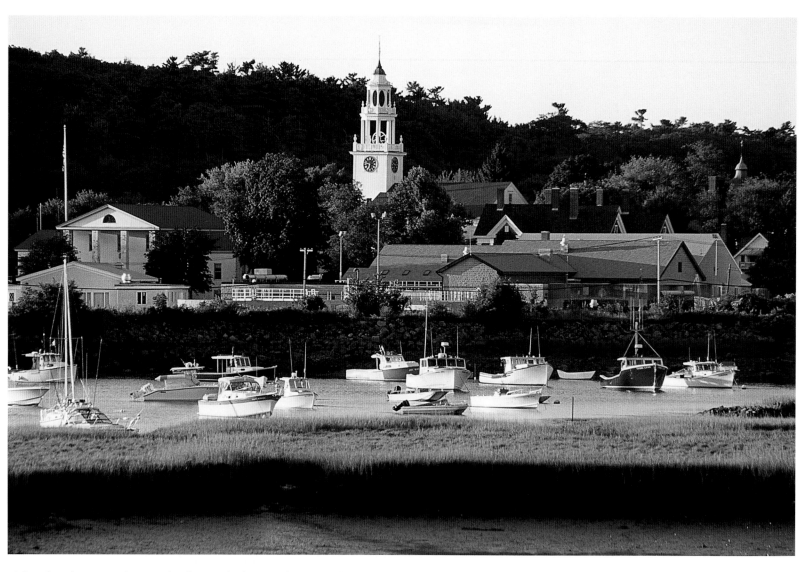

The sky, the trees, the marsh, the sand, the sea: these are the strata, folded one upon another, that make Manchester (above) and so much of the North Shore so beautiful. In the Old Burial Ground in Manchester, gravestones stand shaded by trees as old as they.

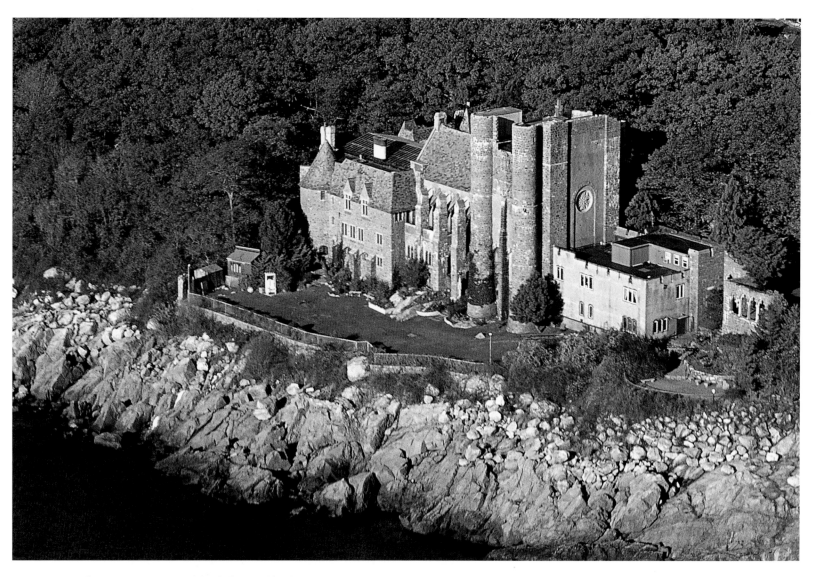

John Hays Hammond built his "Abbadia Mare" in the late 1920s as a home and a museum. Children and adults alike are fascinated by its drawbridge, moat, parapets, turrets, and secret passageways.

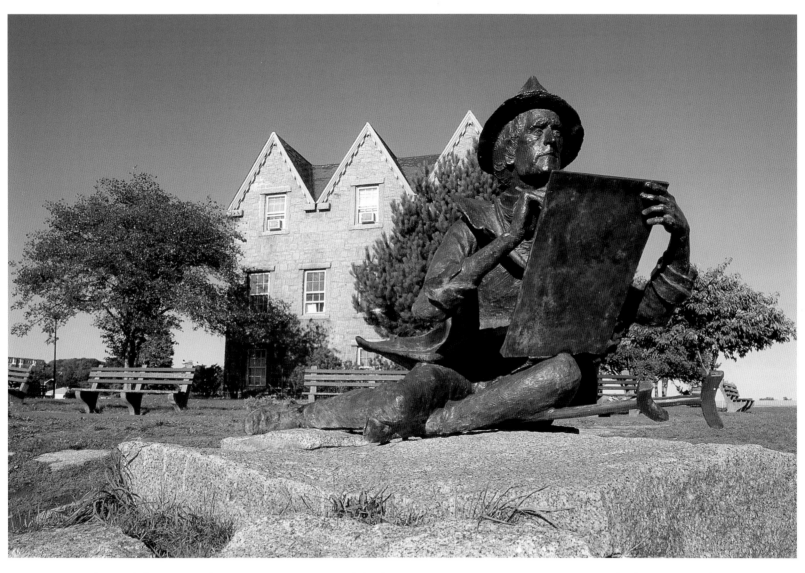

In front of the Fitz Hugh Lane House, a statue of the luminist painter (1804–1865) gazes toward Gloucester Harbor, where so many of his vivid paintings are set.

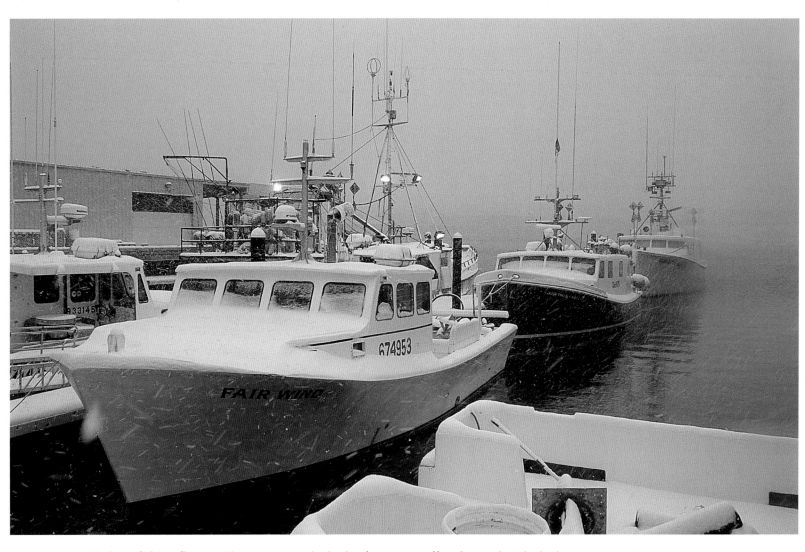

Today's fishing fleet in Gloucester may be built of sterner stuff and armed with the latest navigation equipment, but it must brave sudden winter storms just as its ancestors did.

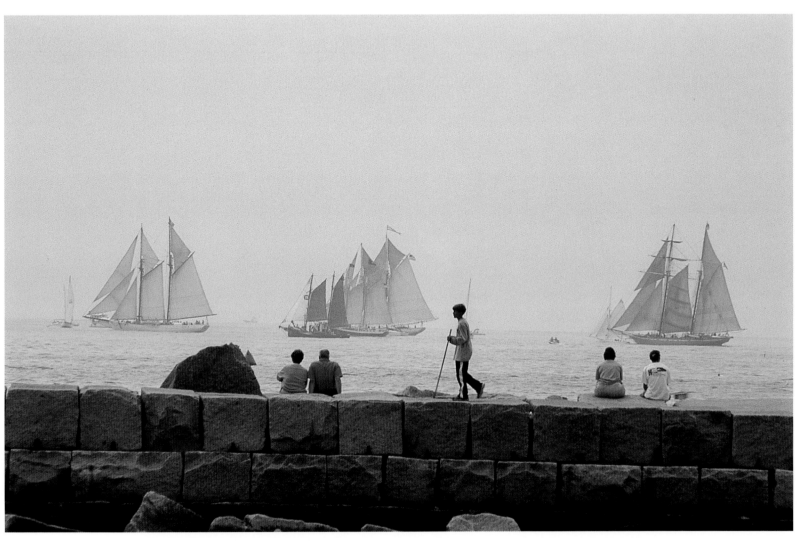

Like ghost ships from another time, schooners race past the Eastern Point breakwater.

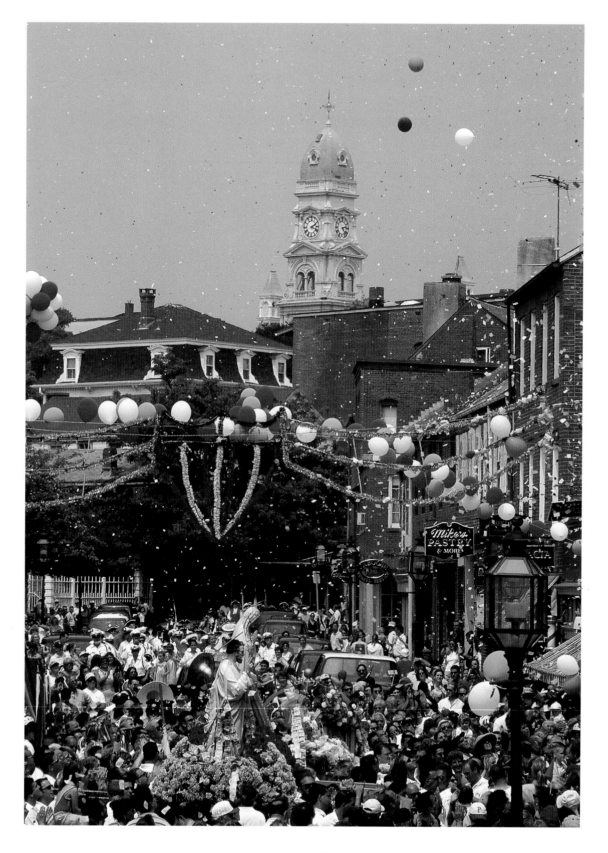

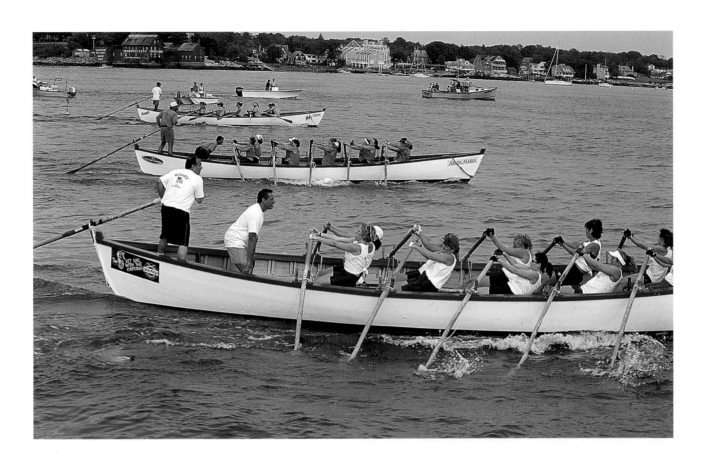

The St. Peter's Fiesta, sponsored by the Italian-American fishing community of Gloucester, celebrates the memory of St. Peter and the glory of Gloucester with parades (left), seine boat races (above), and a "greasy pole" contest (right). The winner must walk the length of the pole and grab the red flag at the end before tumbling into the water below.

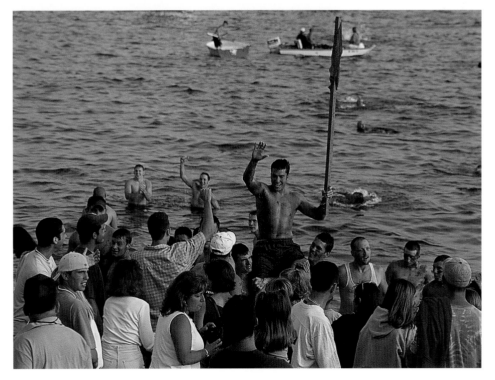

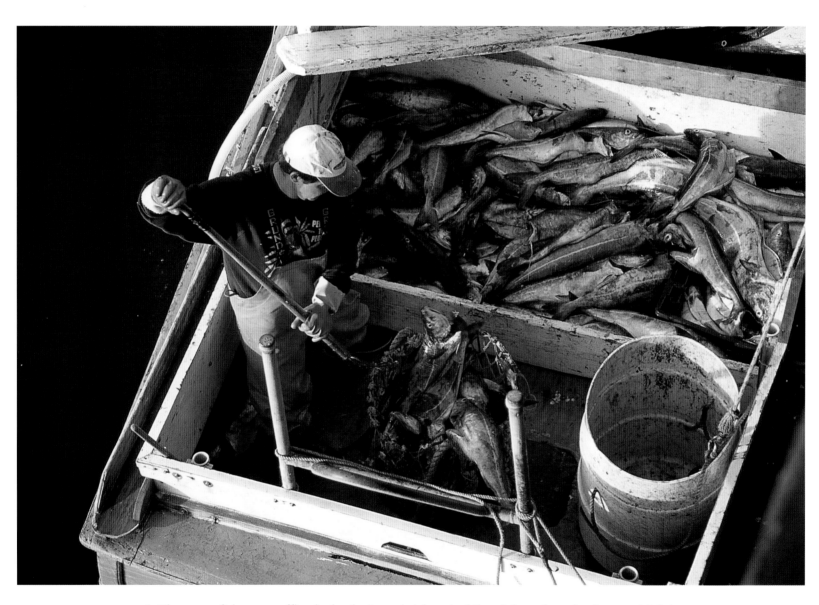

A Gloucester fisherman offloads the day's catch (above) while a lobster boat loads traps (right).

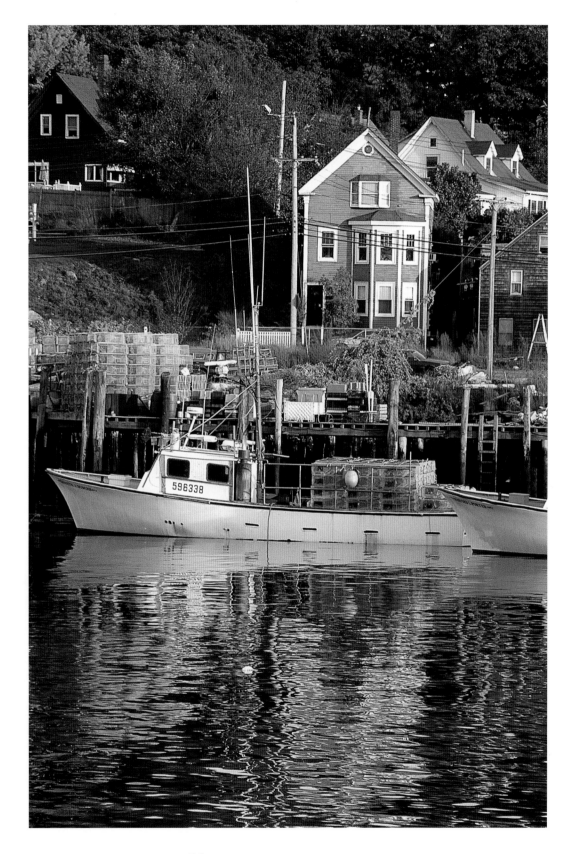

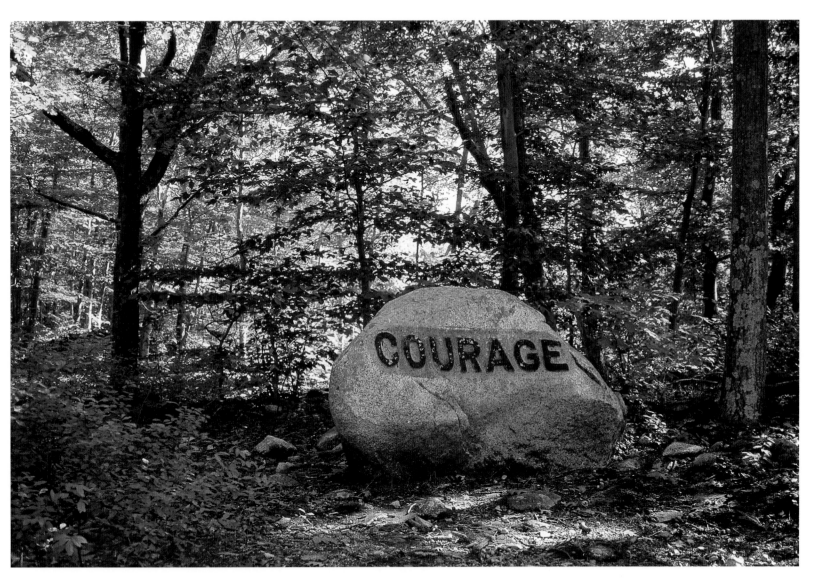

Sculptress Morgan Faulds Pike stands beside her Gloucester Fishermen's Wives Memorial (left). The motto for the countless women and children who waited for their husbands and fathers might well be "Courage." In fact, this exhortation (above), one of a series that economist Roger Babson hired stonecutters to carve, appears on a rock in Dogtown, an abandoned village at the heart of Cape Ann. Other inspirational "Babson Boulders" encourage explorers of Dogtown to "Study" and "Be on Time."

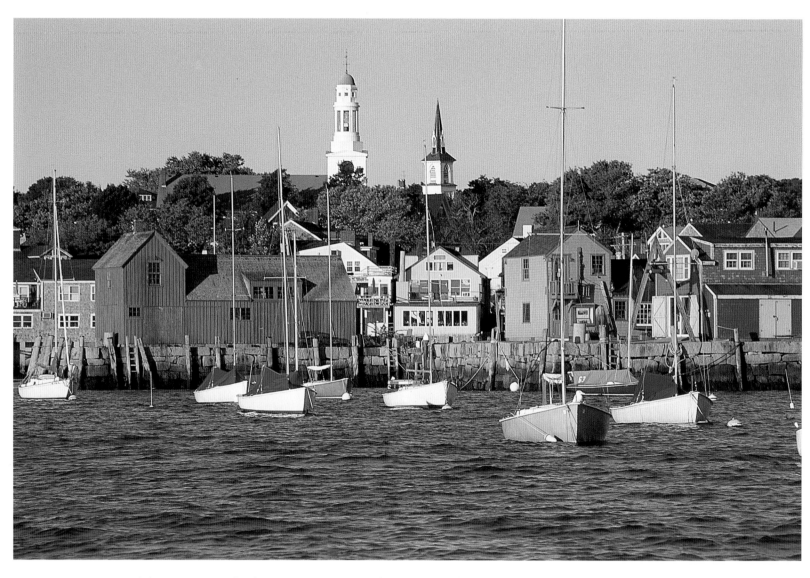

One of the most painted subjects in America, Rockport's "Motif No. 1," stands at the end of Bradley Wharf, greeting all who enter the harbor.

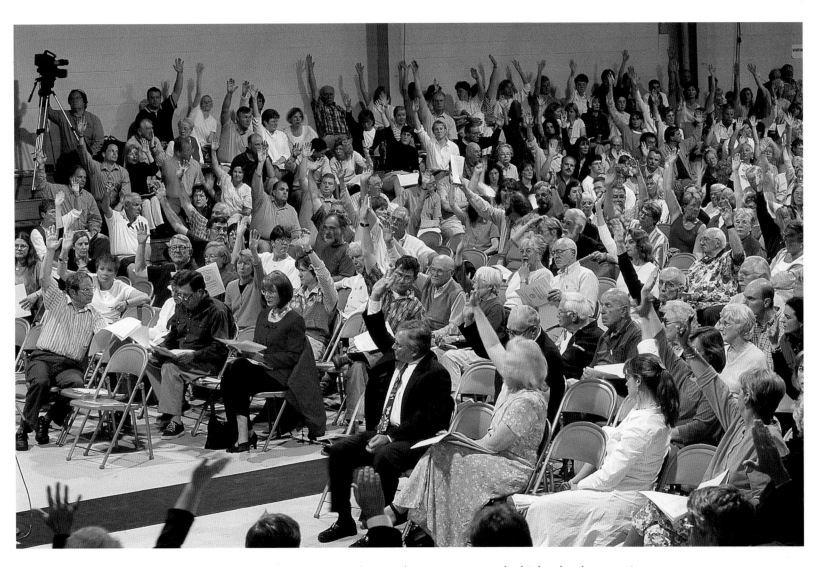

Rockport's annual town meeting draws a heavy turnout at the high school gymnasium.

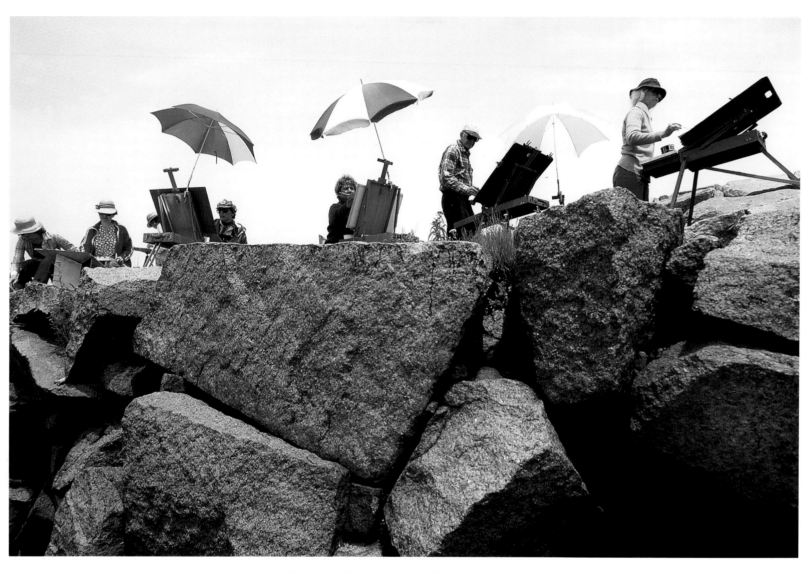

A juxtaposition of granite and fine art—the two themes for which Rockport is probably most famous.

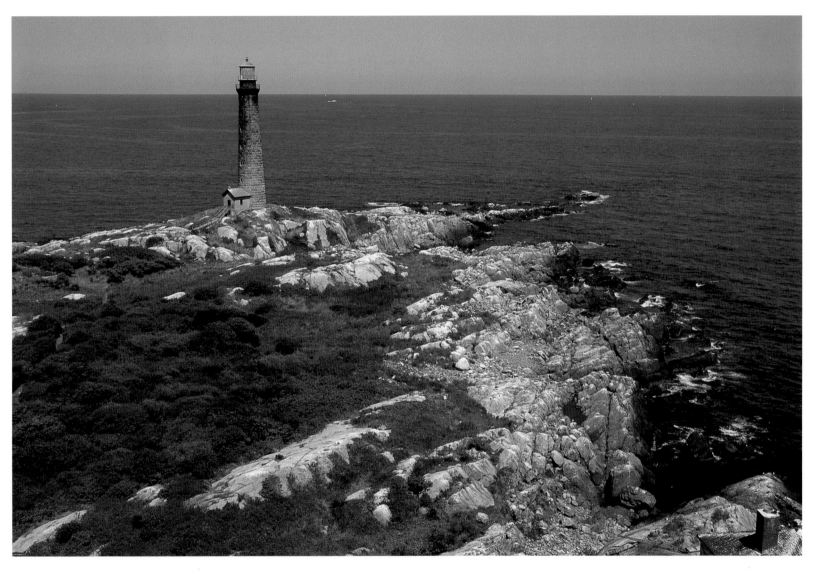

One of the 124-foot Twin Lights of Thachers Island warns mariners away from the shoals east of Rockport. The first recorded shipwreck in New England occurred here in 1635, and the island was granted to the only survivors, Anthony Thacher and wife, who lost their children in the disaster.

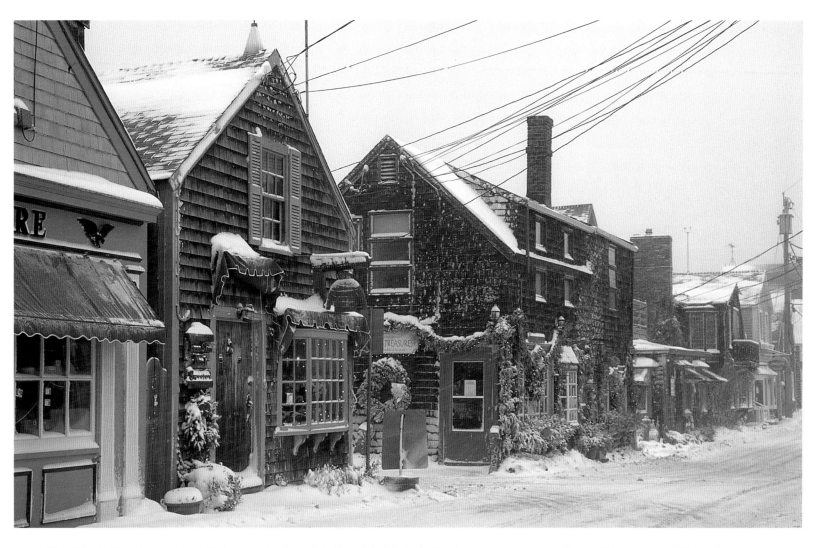

The North Shore's quaintest little stretch of road is Bearskin Neck in Rockport—never more beautiful than in a blizzard (above), though in the warm months (right) it is a shopper's pleasure and a painter's treasure.

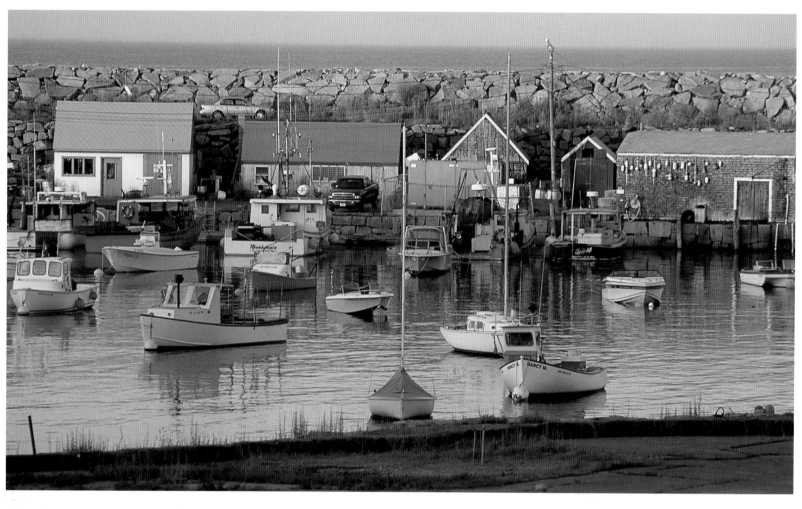

Following Route 127 along the back side of Cape Ann leads through a succession of villages, including Pigeon Cove (above). Behind Wingaersheek Beach, a sail glides along the Jones River (right).

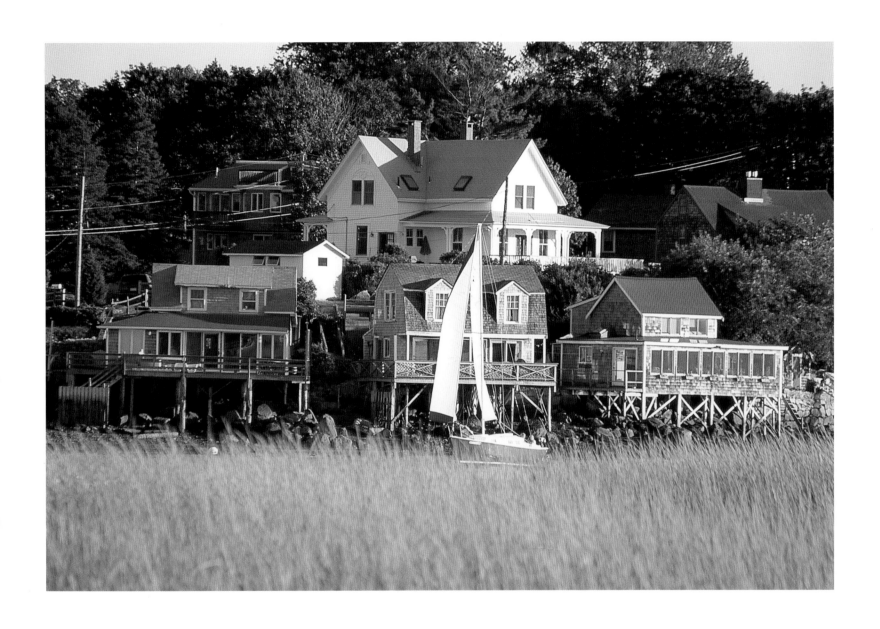

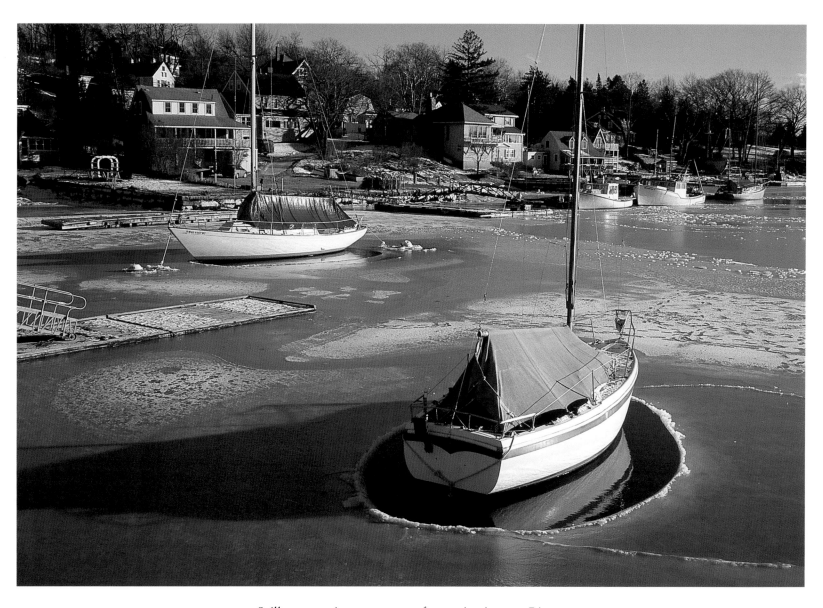

Sailboats await summer on a frozen Annisquam River.

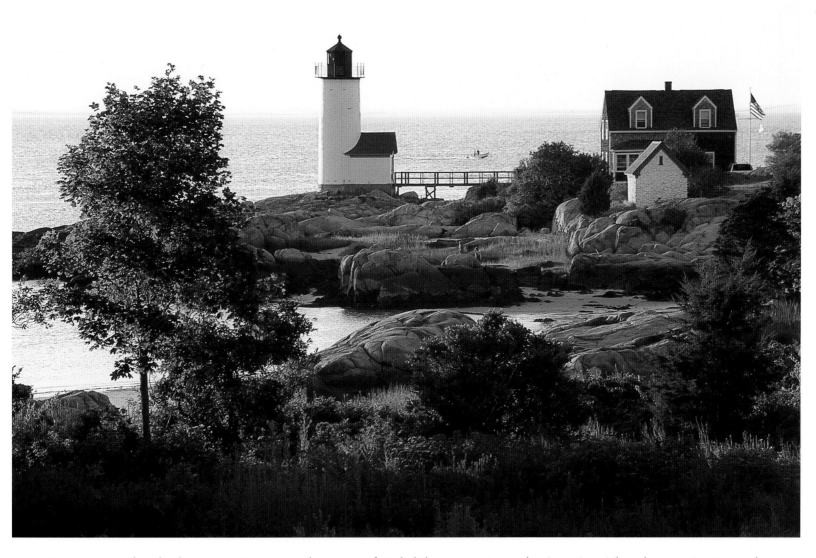

Annisquam Light, also known as Wigwam Light, is one of six lighthouses ringing rocky Cape Ann. The others are Straitsmouth, the Twin Lights of Thachers, Ten Pound Island, and Eastern Point.

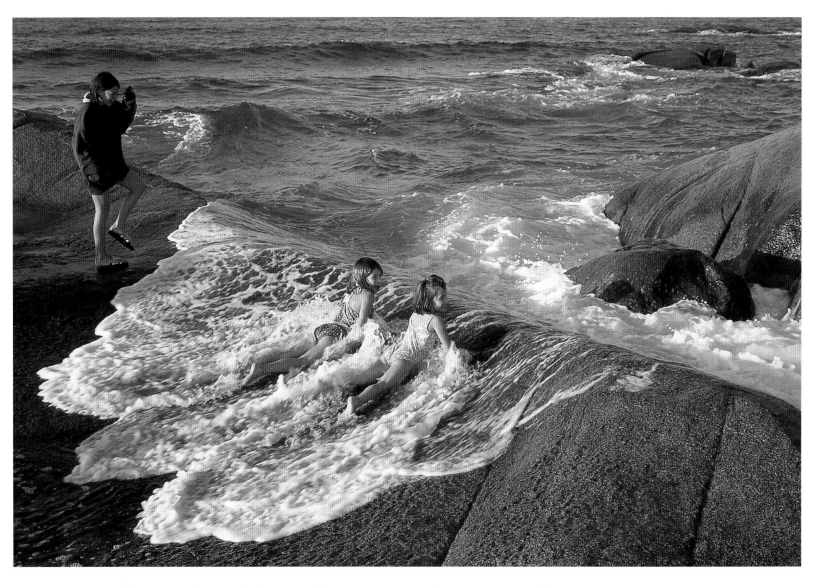

Gloucester's Wingaersheek Beach offers a happy respite from summer heat (above) and a gracious view of the Annisquam Yacht Club across the river (right).

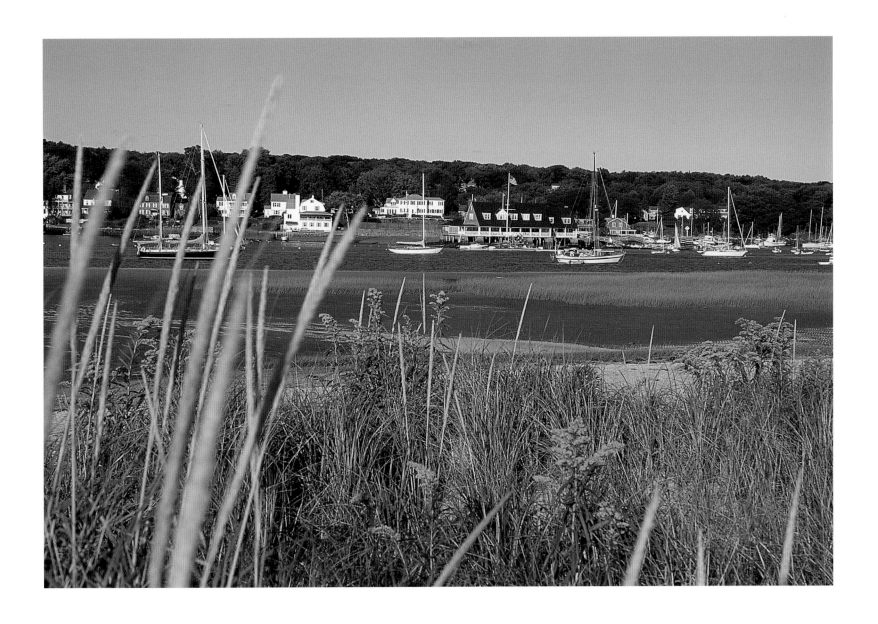

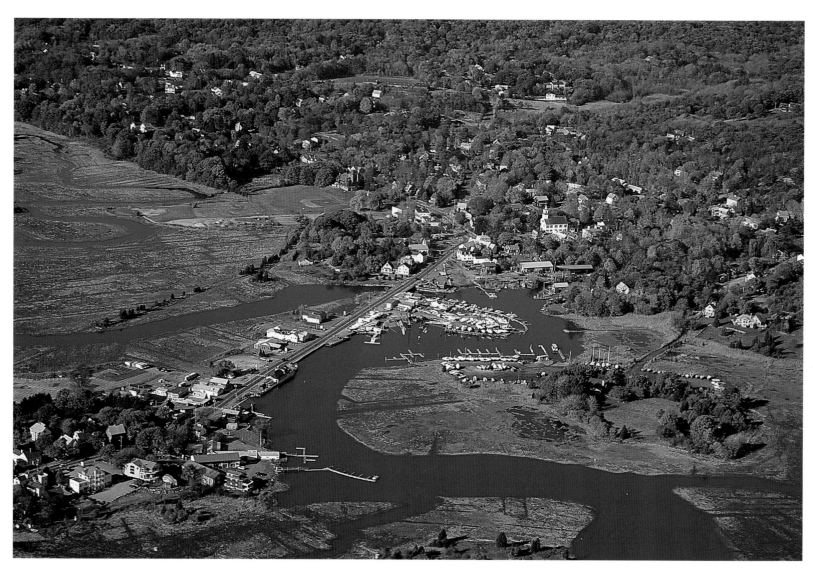

Essex is the town that built the ships that carried the men who caught the fish that fed the shore—and much of the rest of the world. From boatyards up river the finished hulls were floated downstream at high tide and out into Ipswich Bay (to the right in the picture above).

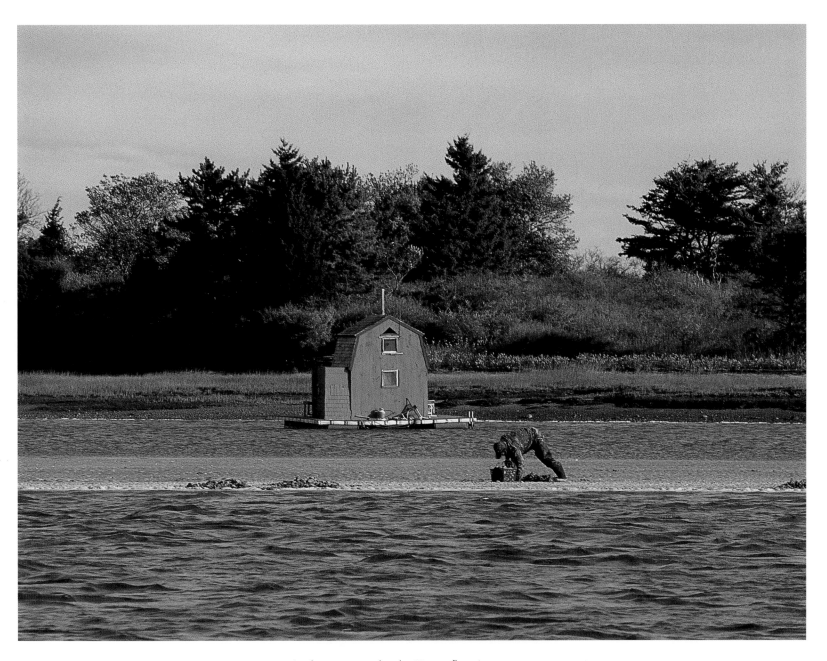

A clammer works the Essex flats in autumn.

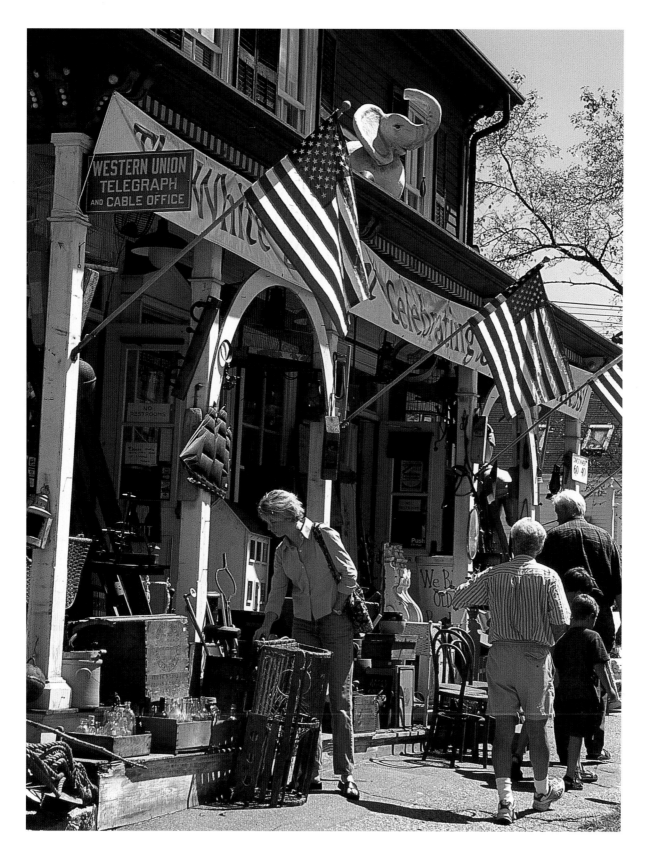

Antiques, fried clams, and lobsters on a steaming
August night are just some of the pleasures of Essex,
where the town hall, built in 1893, welcomes visitors.

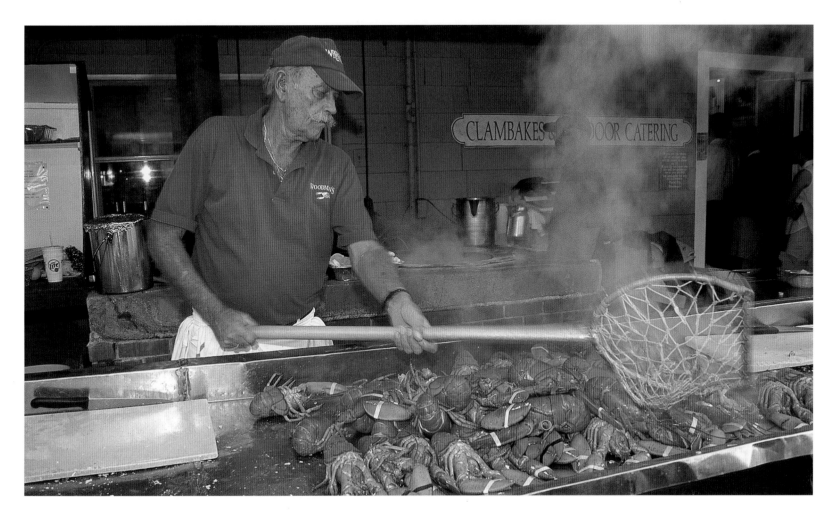

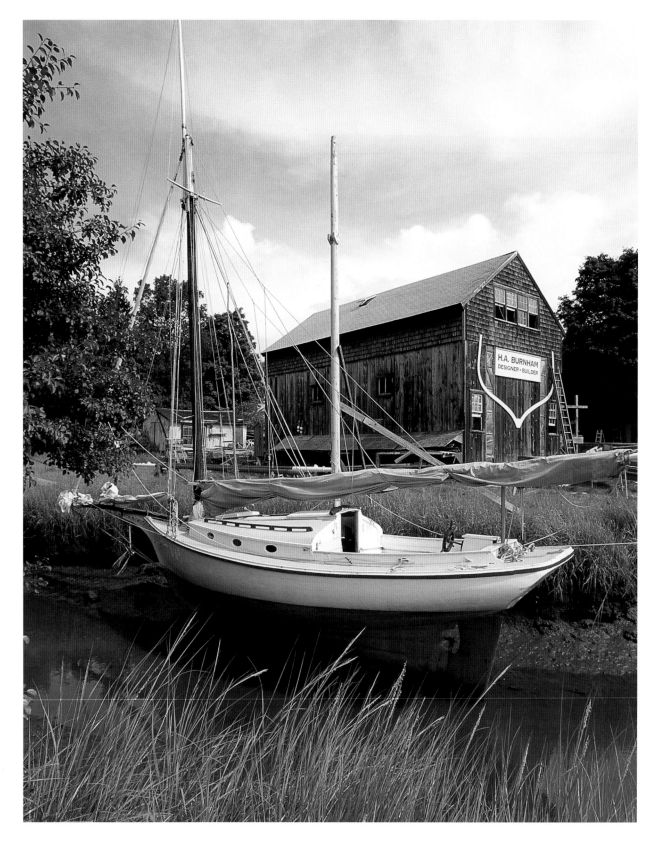

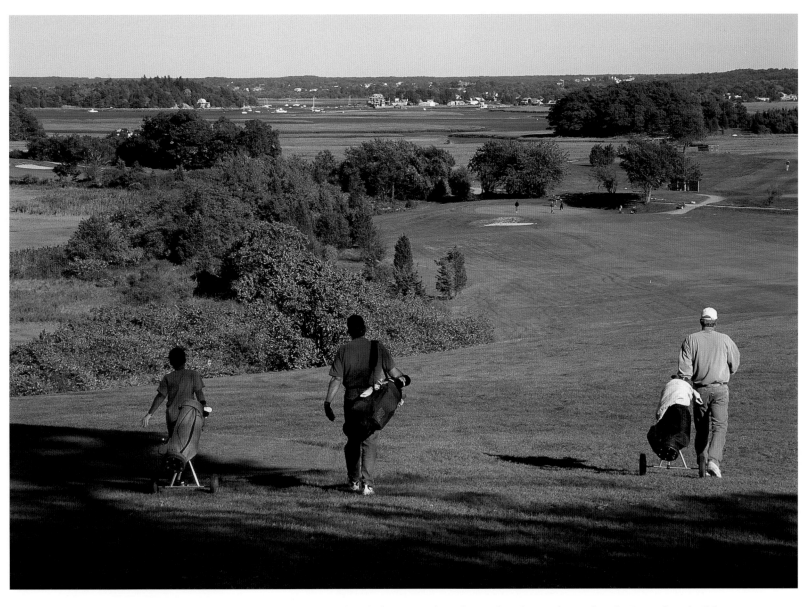

The Burnham Boat Yard, still active in Essex today (left), is run by a latter-day descendant of early Essex boatbuilders. The Cape Ann Golf Course on Route 133 between Essex and Ipswich offers some of the more spectacular views during a summer nine.

THE UPPER SHORE

Above Cape Ann, marsh takes over from ledge, and wildlife abounds. The human history of this stretch of shore is abundant, as well.

Ipswich (right), settled in 1633, was, with Boston and Salem, one of the three most important towns in the early Massachusetts Bay Colony, and it has as its legacy America's largest collection of first-period (seventeenth-century) homes, with more than forty homes built before 1725 still standing. Yet certainly its most noted dwelling is the Great House at Castle Hill (below), built nearly three centuries after the town's founding by Richard T. Crane.

Newburyport, by contrast, boasts a magnificent display of federalist architecture, reflecting the town's coming to prominence in the period immediately after the Revolution, when it was a shipbuilding and seagoing power. A devastating fire in 1811, and an ordinance passed afterward, accounts for the characteristic brick architecture of Newburyport's downtown, a redevelopment success story.

Around these towns of the upper shore, rural New England begins to take over—from Rowley, with its village green and bandstand, antique shops and flea markets, to Amesbury and Salisbury, two towns with heart and history astride the Merrimack. Of all the settlements near the river's mouth, however, Newbury deserves pride of place. Newburyport, much bigger now, was once just an upstart neighborhood split off from this parent. The village of Byfield (located within the boundaries of Newbury) and town of West Newbury are two more splinters of the original Newbury.

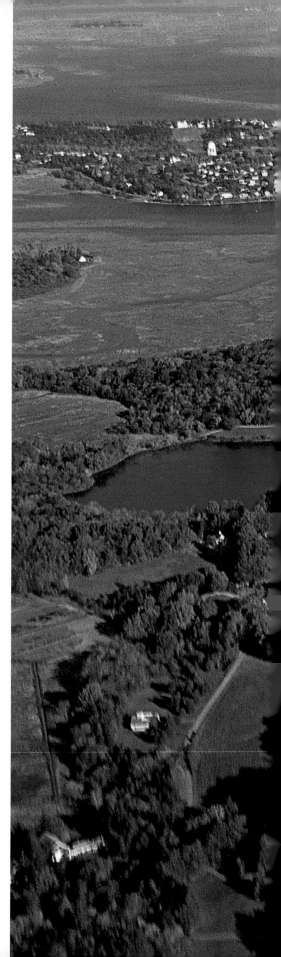

96

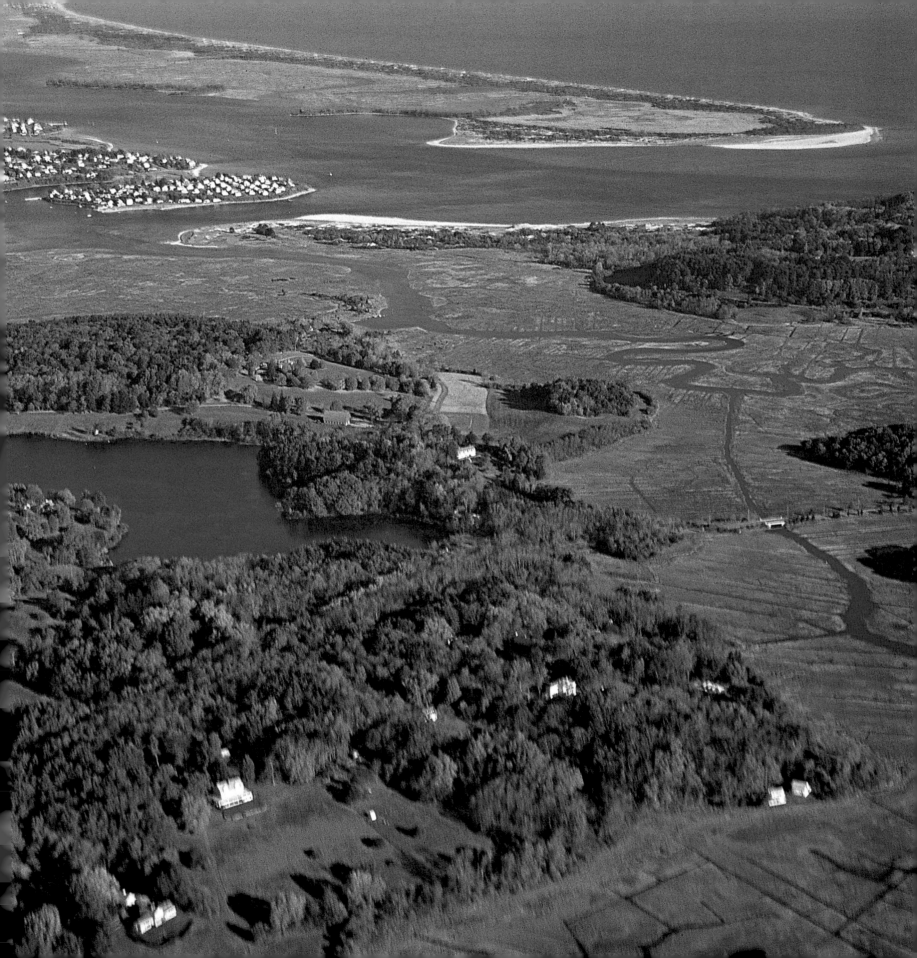

Crane Beach (left and below), four and a half miles of summer enjoyment, was the bequest of the Crane family, who lived above it on Castle Hill. Their lands are now owned by The Trustees of Reservations. In the Grand Allée leading from the Great House to the sea (right), car lovers ogle antiques during the popular Concours d'Elégance.

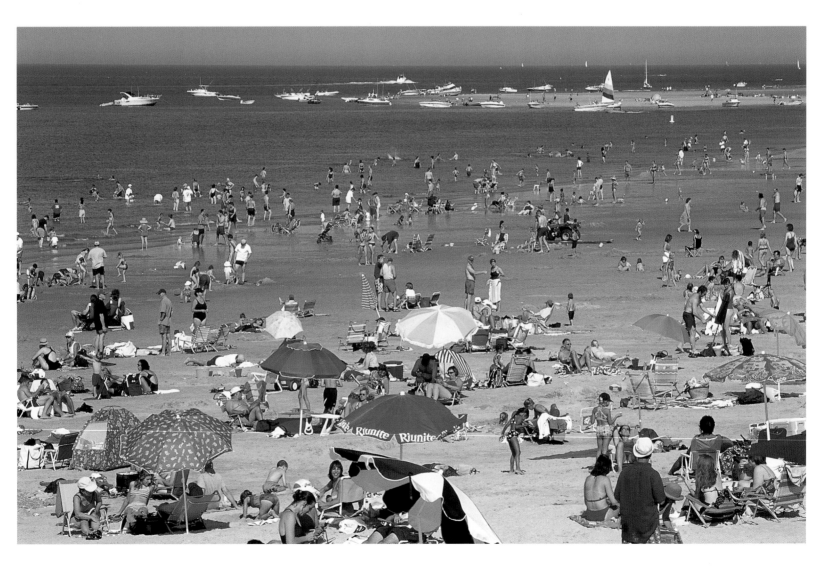

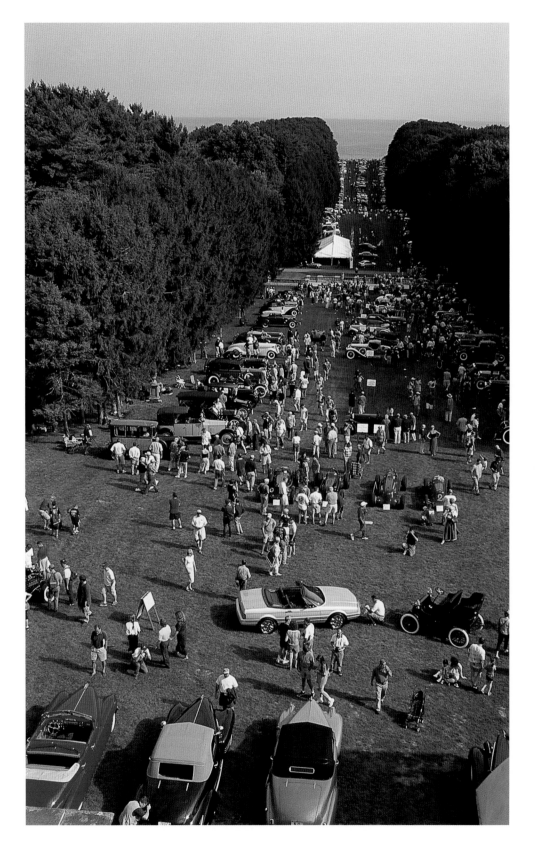

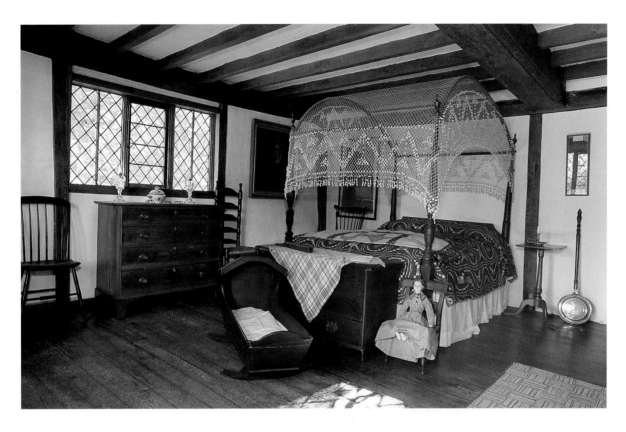

Ipswich celebrates its diverse heritage, from the early English influence visible at the Whipple House (above), owned by the Ipswich Historical Society, to a joyous dance at the Hellenic Community Center (right), founded by Greek Americans.

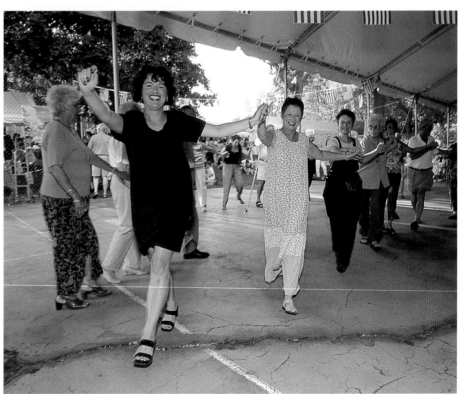

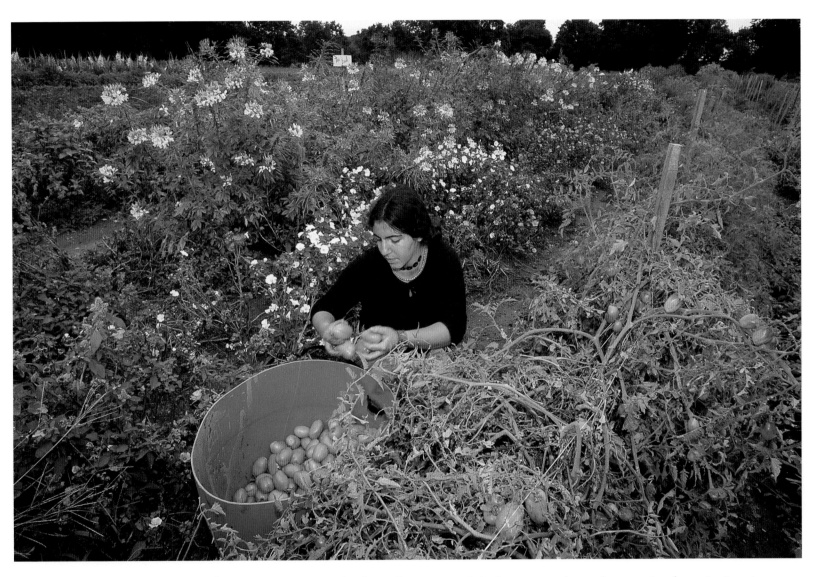

A volunteer harvests organically grown tomatoes at Appleton Farms, one of the longest continuously operating farms in America, now owned by The Trustees of Reservations. At 1,000 acres, Appleton Farms is located in both Hamilton and Ipswich.

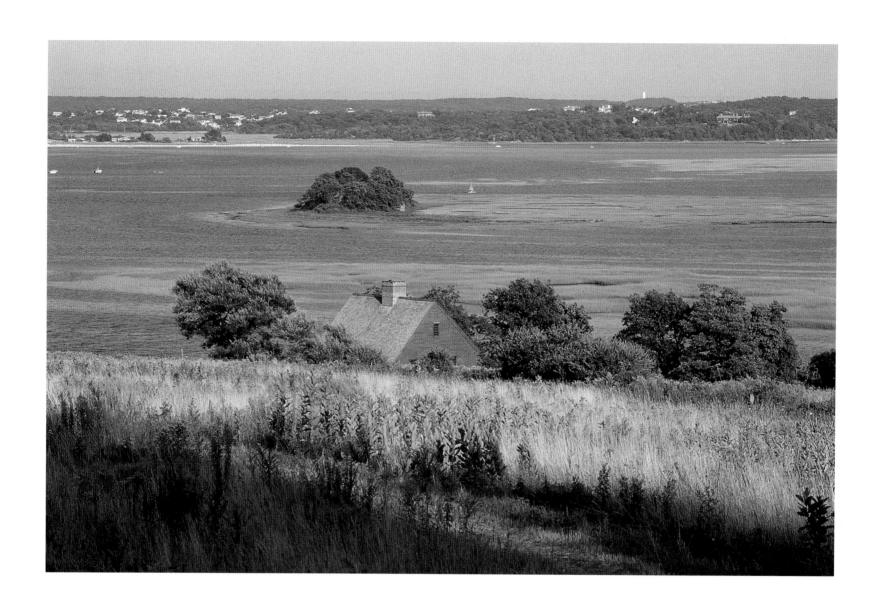

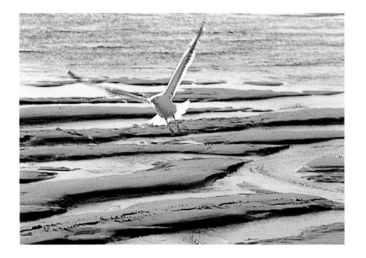

The Choate House and Hog Island on which it sits (left) offer a breathtaking view of Plum Island and the Atlantic beyond. A gull swoops over Plum Island's flats (right), while a couple surf-casts off her beach (below). Four towns lay claim to stretches of Plum. From south to north, they are Ipswich, Rowley, Newbury, and Newburport.

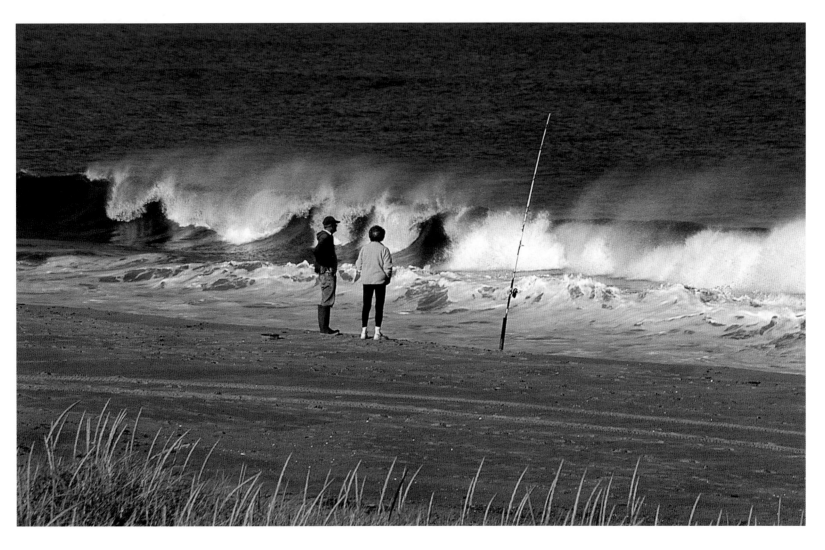

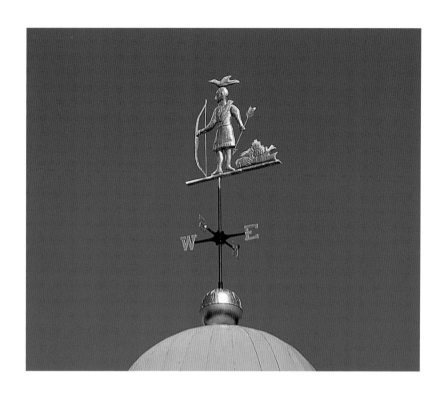

Before European settlers came, the Agawams lived in the region around Ipswich and Rowley. The weathervane on Rowley's town hall (left) honors this heritage, while one of New England's legendary diners (below) still bears the Native Americans' name. Rowley is also a magnet for those (right) who love shopping for antiques and whatever else the flea markets are offering this weekend.

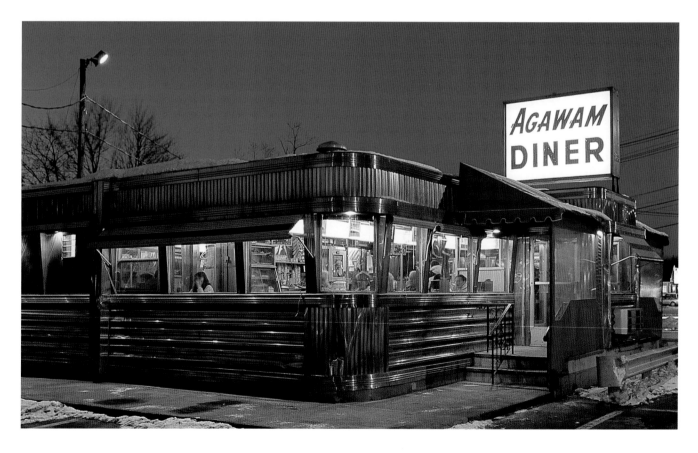

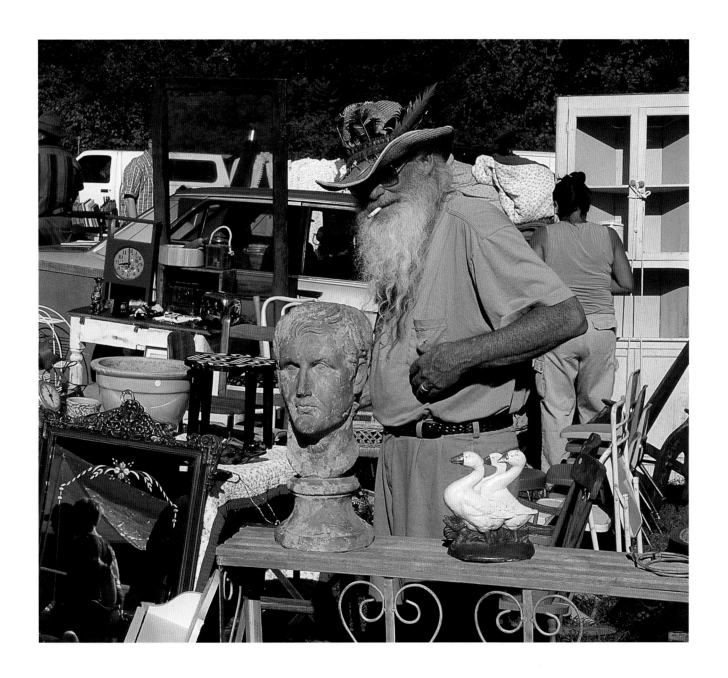

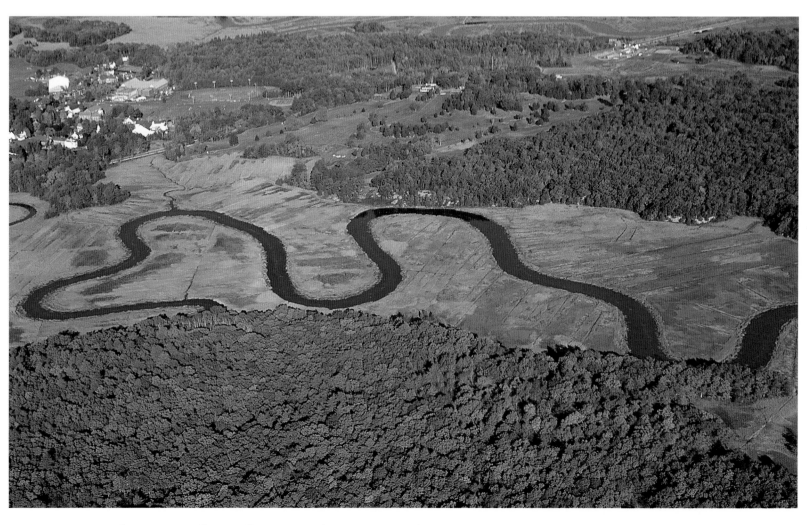

The sinuous Mill River flows seaward across Route 1 from the oldest boarding school in New England, Byfield's Governor Dummer Academy.

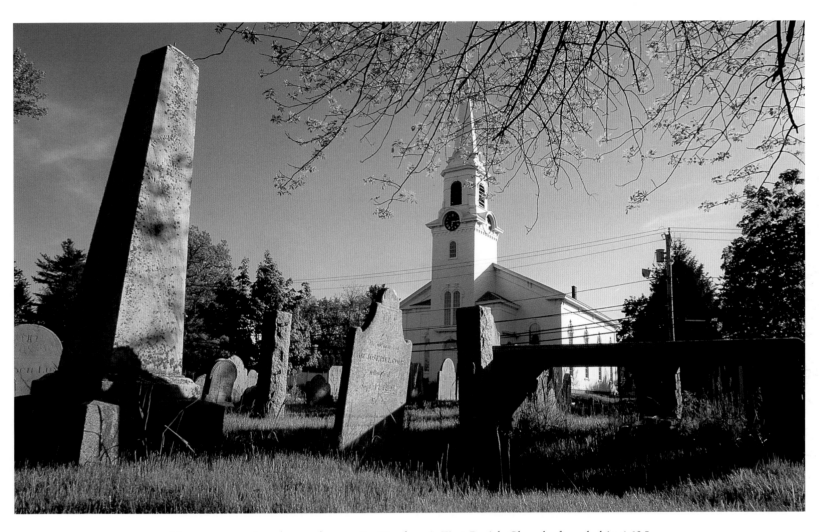

Monuments point skyward opposite Newbury's First Parish Church, founded in 1635.

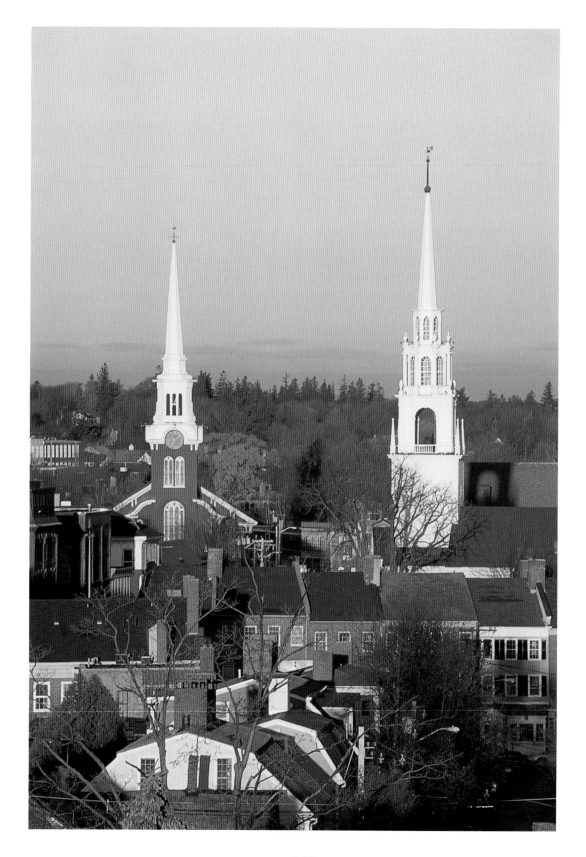

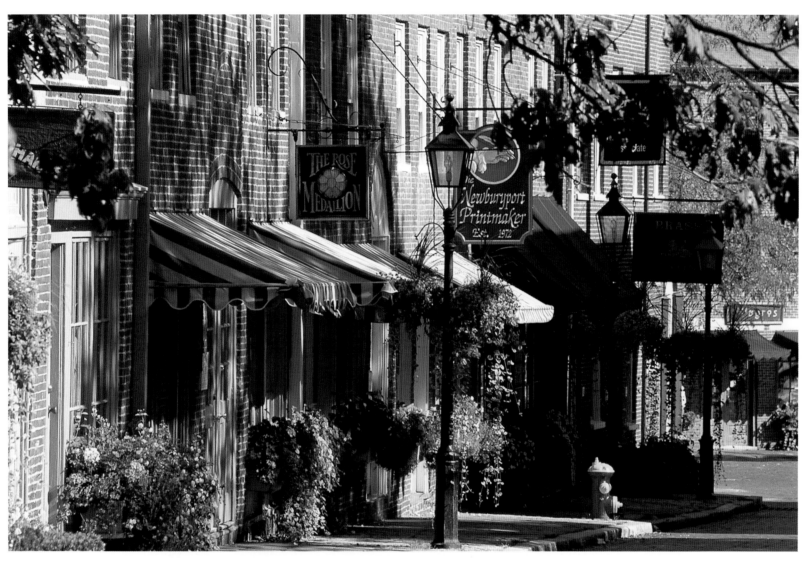

Newburyport, once the smallest city in the Commonwealth of Massachusetts, is one of the loveliest. The spires
of the Central Congregational and Unitarian Universalist churches grace the skyline (left),
while flowers overflow bountifully from storefront windowboxes (above).

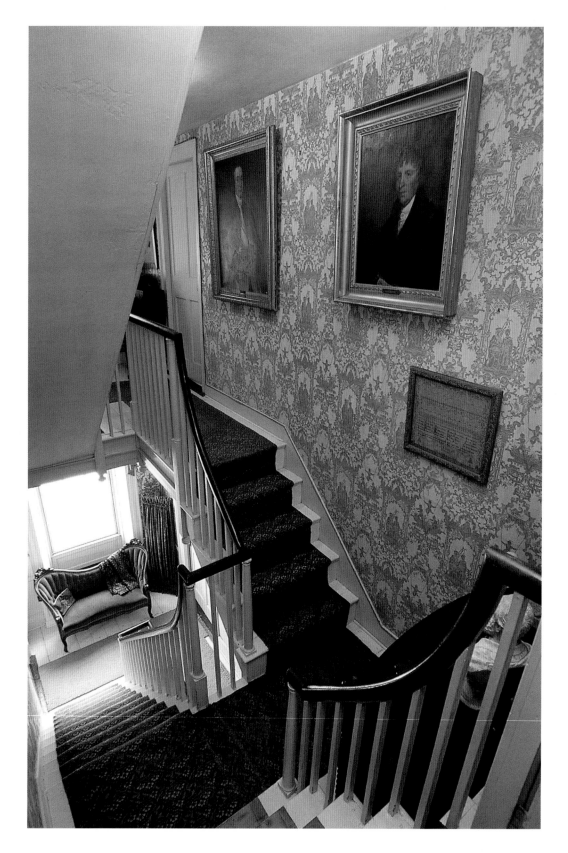

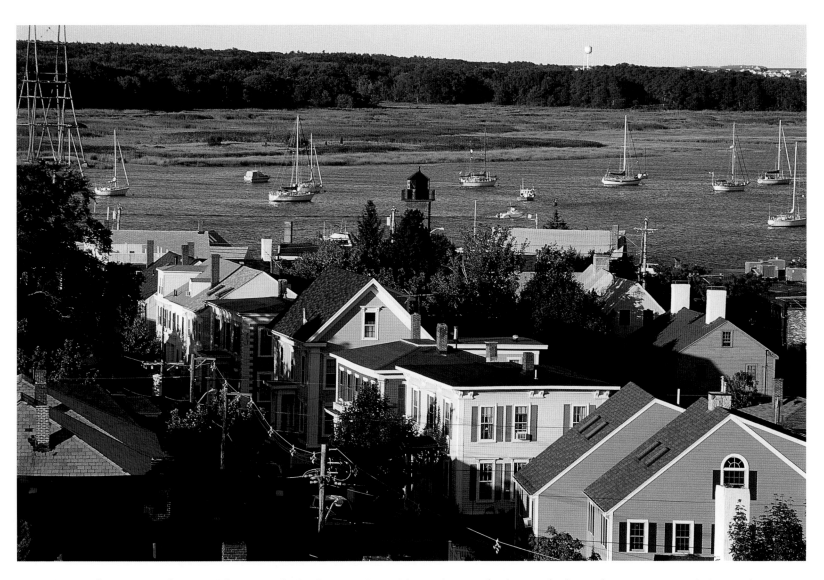

It was the Merrimack River (above), and Newburyport's position at its mouth, that made the settlement so strategic in wartime and so successful in peacetime seagoing commerce. The Caleb Cushing House (left), once owned by a wealthy captain, is one of several Newburyport houses featuring a so-called Good Morning staircase—where captain and wife, emerging from their separate chambers, bade each other good morning.

Up along the Merrimack is Maudslay State Park (above), a 480-acre spread of rolling meadows and pine forests. Farther upriver, in West Newbury, a golden eagle (above right) keeps a lookout above the frozen Merrimack (below right).

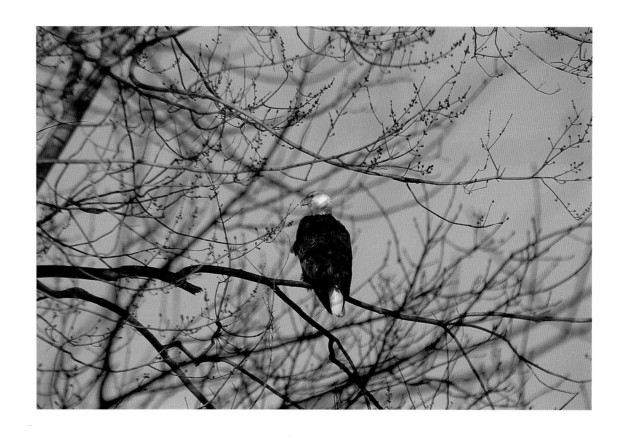

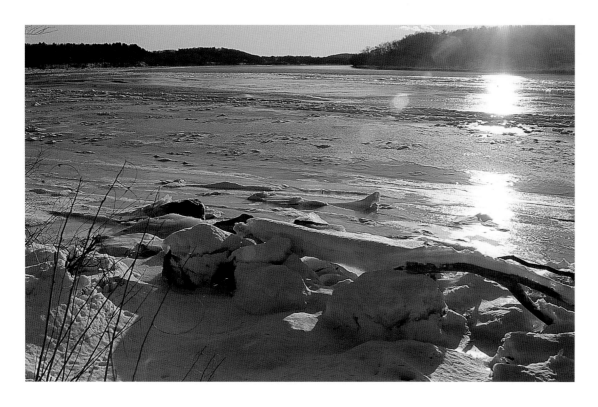

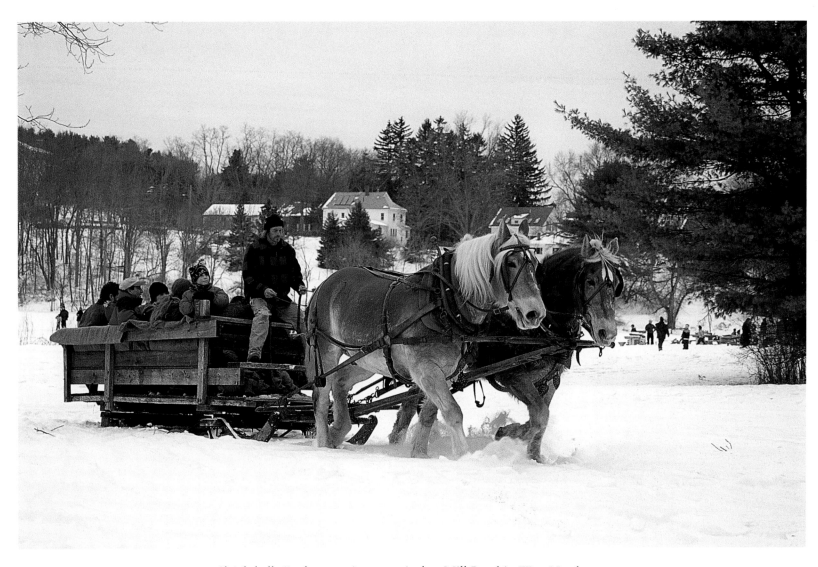

Sleigh bells jingle at a winter carnival at Mill Pond in West Newbury.

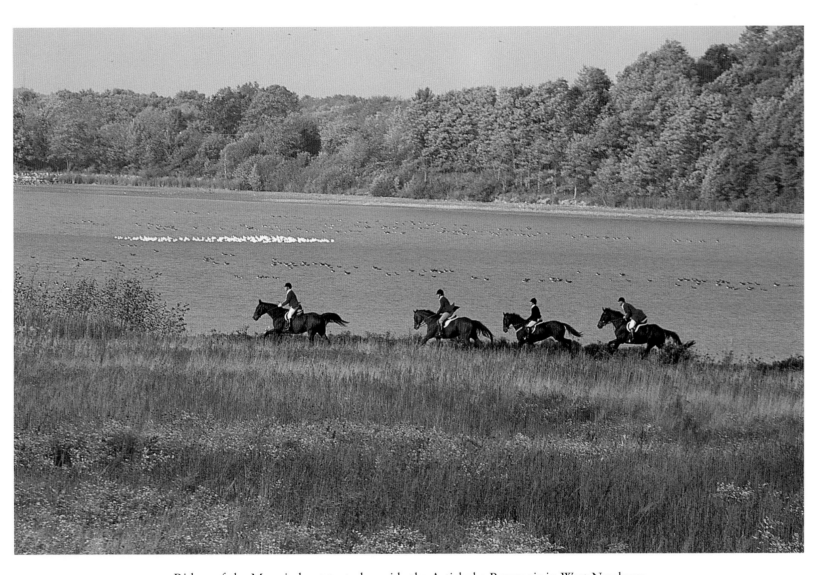

Riders of the Myopia hunt trot alongside the Artichoke Reservoir in West Newbury.

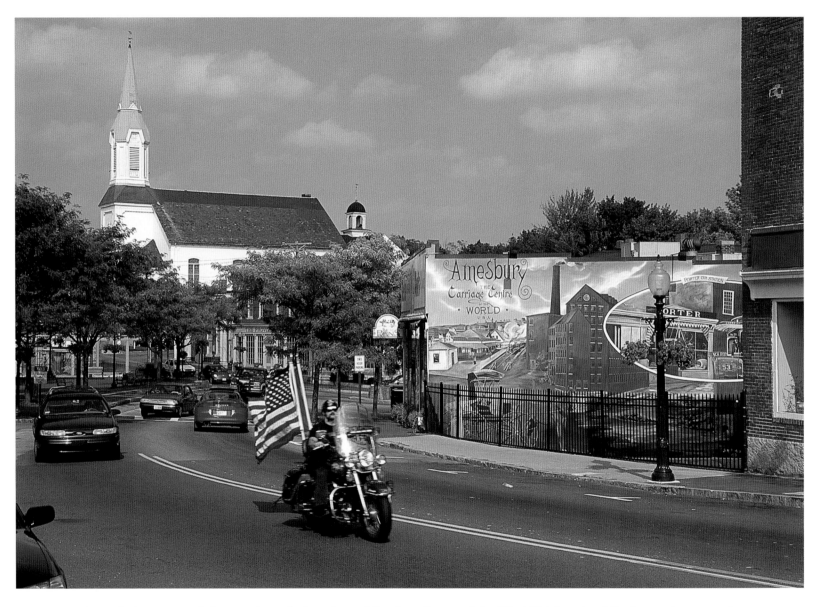

A patriotic motorcycle buzzes through Amesbury, "Carriage Center of the World" (above), while, in a quieter mood, a craftsman attaches oar leathers at Lowell's Boat Shop (right).

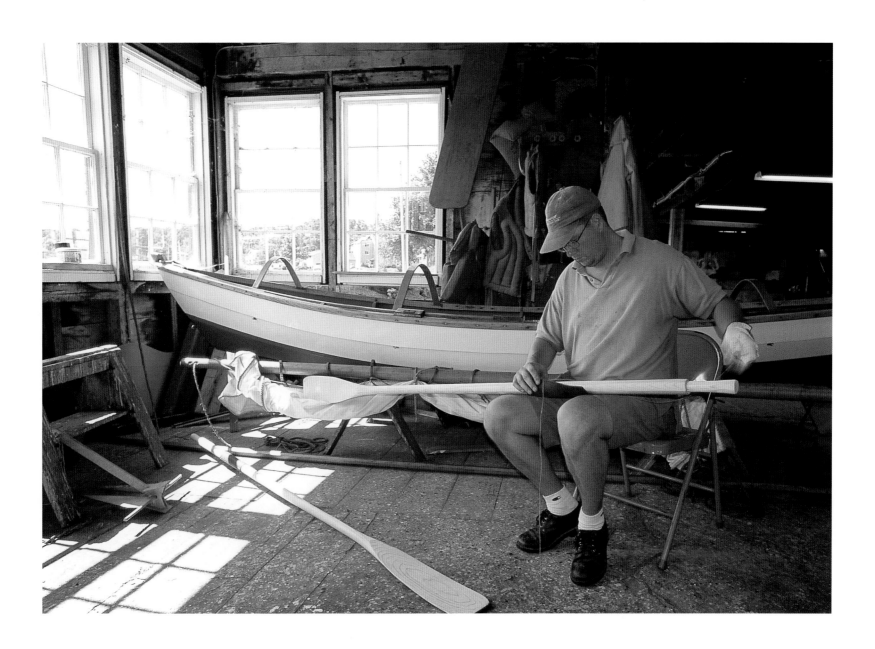

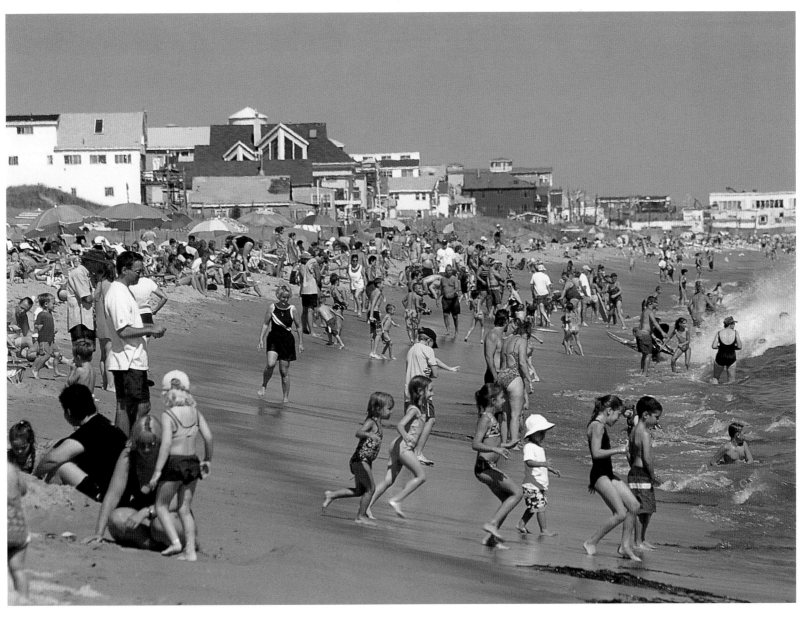

The North Shore is bracketed by crowd-pleasing beaches, Revere Beach at the south end and Salisbury Beach (above) at the north end. On the sands and at the amusement park (left), Salisbury promises affordable family fun.

NOTE FROM THE AUTHOR

The North Shore is a unique area, one that we who live here treasure and those who visit thrill to discover. I have made the region my home and never tire of new discoveries—by boat or by car, on bike or on foot. Historically, culturally, and recreationally, it is like no place else!

This book was a vast task ranging from Winthrop to Salisbury—about twenty-six settlements in all, depending on how you count. I could have filled an encyclopedia, but a 128-page allowance required a strong, sometimes difficult edit. My thanks to my faithful publisher Webster Bull and his wife, Katie; to my editor, Penny Stratton; to fact checker Laura Smith; to designer Joyce Weston; and to production artist Anne Rolland. Great thanks also to my assistant, Dana Mueller, who is of utmost importance in my office. I also want to mention helpful friends, including Gail Majauckas, Paul McNiff, and Marc Hempel, and many of my unnamed friends who were there with ideas and support!

I would also like to acknowledge the co-operation of: Saugus Iron Works National Historic Site; the Saugus River Water Shed Council; RAW Art, Lynn; Northeastern University Marine Science Center, Nahant; Nahant Historical Society; Nahant Victorian Ball; The Swampscott Club; The House of Seven Gables, Salem; The Peabody Essex Museum, Salem; Salem historian Jim McAllister; Paul Madore Chorale, Salem; Marblehead Little Theatre; Marblehead Historical Society; the residents of Hospital Point Light, Beverly; the Cabot Street Cinema Theatre, Beverly; Glen Magna Mansion and Farm, Danvers; Putnam Pantry, Danvers; Essex Agricultural and Technical High School; Myopia Hunt Club, Hamilton; Groton House Farm; Wenham Museum; Wenham Tea House; Asbury Grove, South Hamilton; Topsfield Fairgrounds; Windrush Farm, Boxford; Massachusetts Audubon Society Ipswich River Wild Life Sanctuary; Schooner *Thomas E. Lannon*; Capt. Bill &Sons Whale Watch, Gloucester; The White Elephant Antiques, Essex; Woodman's of Essex; the Essex harbormaster; Cape Ann Golf Course, Essex; The Trustees of Reservations; Hellenic Community Center, Ipswich; Ipswich Historical Society; Lowell's Boat Shop, Amesbury; Todd Farm Flea Market, Rowley; Historical Society of Old Newbury; Long Hill Orchards, West Newbury; and Maria Miles of the Salisbury Chamber of Commerce. I appreciate the assistance and cooperation you gave. Thank you!

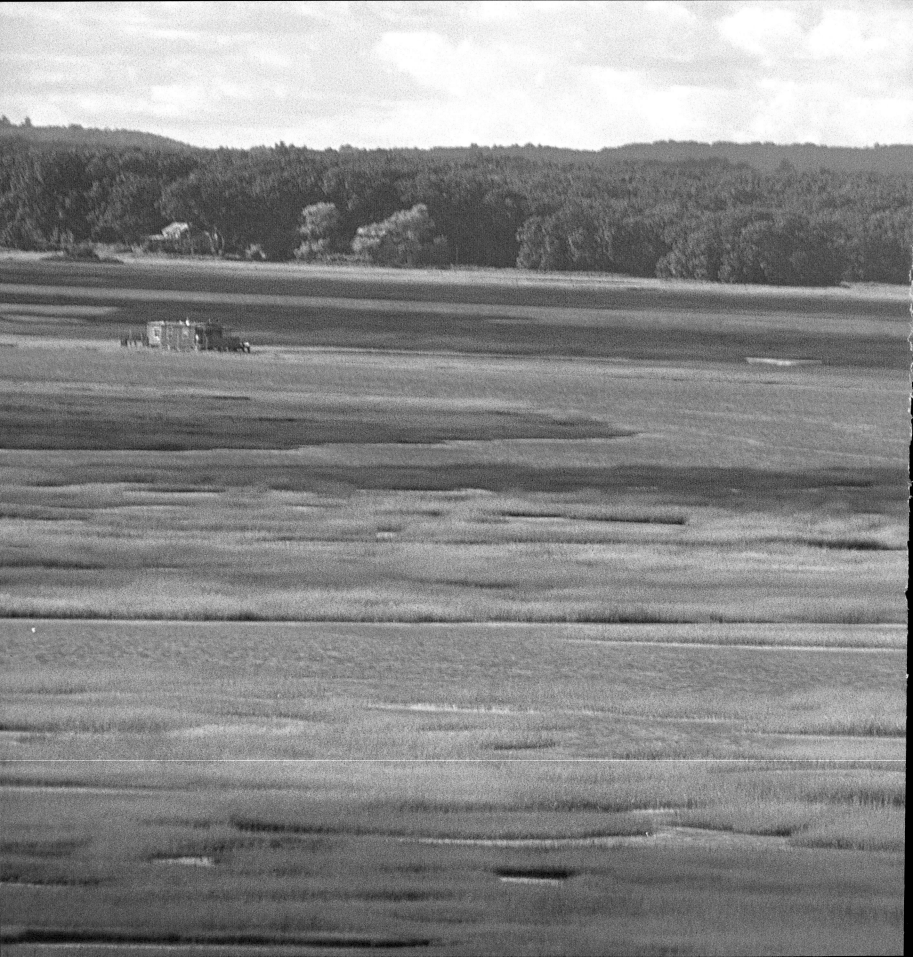